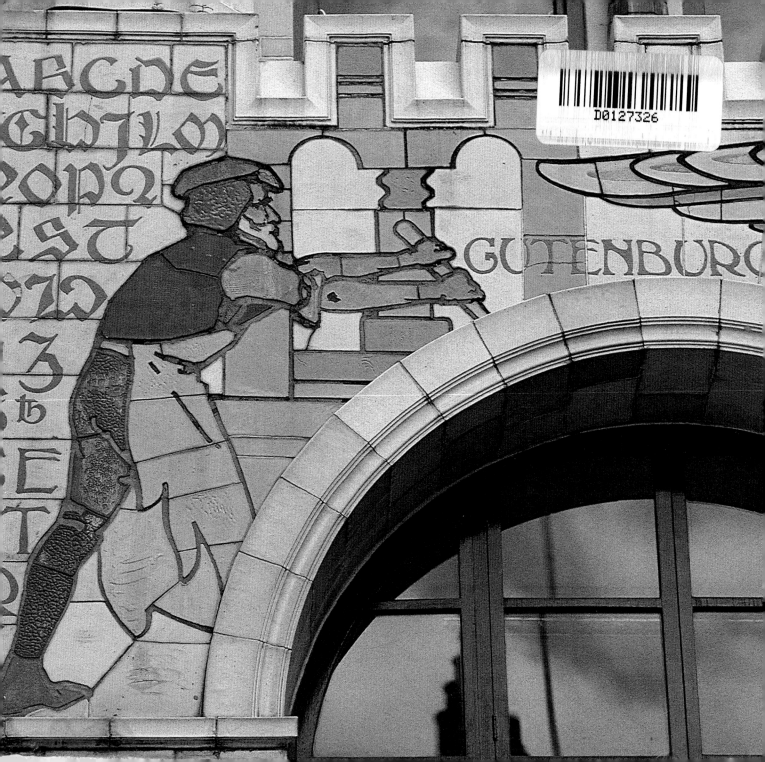

DESIGNAGE

The Art of the Decorative Sign

ARNOLD SCHWARTZMAN

CHRONICLE BOOKS · SAN FRANCISCO

Right:
Leaded glass window,
"Isolde,"
Glasgow School of Art.
Artist / Designer:
Dorothy Carlton Smyth
Architect:
Charles Rennie Mackintosh.
Glasgow, Scotland, 1901.

Printed in Hong Kong

ISBN 0-8118-1962-0

Library of Congress Cataloging-in-Publication Data available.

Book and cover design:
Arnold Schwartzman
Photography:
Copyright © 1998 Arnold Schwartzman
Composition:
Set in Perpetua by Isolde Schwartzman

Distributed in Canada by Raincoast Books
8680 Cambie Street
Vancouver, B.C. V6P 6M9

10 9 8 7 6 5 4 3 2 1

Chronicle Books
85 Second Street
San Francisco, California 94105
Web Site: www.chronbooks.com

Endpapers: *Detail of*
Edward Everard's
art nouveau printing shop.
Doulton Carrara-ware tiles.
Architect: Henry Williams.
Tile decoration: W. J. Neatby.
Bristol, England, 1901.

Frontispiece:
Signmaker's painted wall.
Paris, late 19th century.

FOR ISOLDE

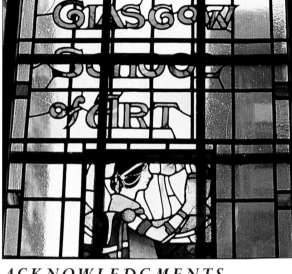

ACKNOWLEDGMENTS

I wish to express my gratitude to my friends who have helped me in the preparation of this book, in particular Ben Bos; Dr. Alan Borg, CBE; Lesley Bruynesteyn; Len and Ysabele Deighton; Paul Dimond; Glasgow School of Art; Carole Goodman; Alan and Paola Fletcher; Professor Malcolm McLeod; Nigel Roche, St. Bride's Printing Library, London; Hannah Schwartzman; Gerard Wernars; and to my wife Isolde, who once again has patiently executed this book's production.

CONTENTS

INTRODUCTION

HENEVER I ENTER A HOTEL and step over the welcome mat, I am reminded of my father, a former maitre d' at London's famed Savoy Grill Room. When he later managed his own hotel, he ordered an enormous coconut–hair doormat for its foyer. Being a keen amateur signwriter, he carefully sketched out the hotel name and the precise position where it should appear. Some weeks later, the eagerly awaited mat arrived, printed with two-foot-high letters: MAJESTIC HERE!

Inset: *Jugendstil (art nouveau) initial "W." Vienna, 1890s.*

The error of including the word *here* would seem to echo one of my father's favorite stories about a signwriter who was trying to convince a fishmonger to put up a sign stating FRESH FISH SOLD HERE. The shopkeeper declined, explaining, "Well, of course my fish is fresh, so you don't need the word fresh. You can see that I sell fish, and obviously I'm not giving it away," thus leaving only the word *here* to be lettered.

Growing up in London, I observed the proliferation of hand-lettered signs on shop fronts and public houses. Many of these fine examples of the signwriter's art were destroyed during World War II. However, a beautifully lettered set of High Victorian mirrors, which had been covered up for protection during the London Blitz, were recently discovered behind a false wall in a London public house. A gilded shop sign I had previously photographed had been removed, revealing a most ornate Victorian painted sign. This, in turn, has now been replaced by a copy of the earlier sign. Likewise, after the devastating 1994 Los Angeles earthquake, I found an example of a 1930s Coca-Cola sign revealed on a retaining wall—this has since been painted over.

Moving to Hollywood, California, in 1978, I exchanged the familiar landmark of Piccadilly Circus's neon signs for the Hollywood sign—probably the only town in the world that has a

Opposite: *Art deco mosaic entrance-way to the Café Américain, American Hotel. Amsterdam, 1928.*

sign as its symbol—a unique landmark in that it was adapted from a realtor's sign that over the years ran into disrepair. Realizing its importance as an icon to the city, it was restored with donations from a few entertainment luminaries.

During the excavations of the ruins of Pompeii and Herculaneum, some nine hundred pictorial shop signs were discovered, many painted and gilded. Despite this clear evidence of signage in the ancient world, it was not until the invention of printing by Johann Gutenberg in the fifteenth century, and the spread of literacy, that the written sign came into general use.

In England, by the end of the fourteenth century, competition became so fierce for tavern and shop owners that they made their pictorial hanging signs ever bigger in an attempt for recognition. After the Great Fire of London in 1666, some shop owners affixed their signs directly to their buildings' facades. Still, the hanging sign abounded until 1718, when a sign in Bride Lane collapsed due to its enormous weight, killing four passersby and bringing about a law that forbade the hanging sign.

Coincidentally, this is the same narrow lane where, as a student, I studied the history of typography at St. Bride's Printing Library.

In this book, I have chosen to concentrate on several distinct periods and style, i.e. Victorian, art nouveau, and art deco. These examples are sandwiched between the images of two great giants of printing, Johann Gutenberg and William Morris. Other masters of the letterform, such as Charles Rennie Mackintosh and Edward Johnston, are represented in this book. The signwriter, although owing much to type design, was in the main a folk artist, inheriting his style and skills, which were usually handed down as an apprenticeship from father to son. Today, signwriting is becoming a vanishing art; however, much can be learned from studying the many techniques used in the various media displayed within these pages.

Opposite: *Painted wall advertisements. Hollywood, 1930s.*

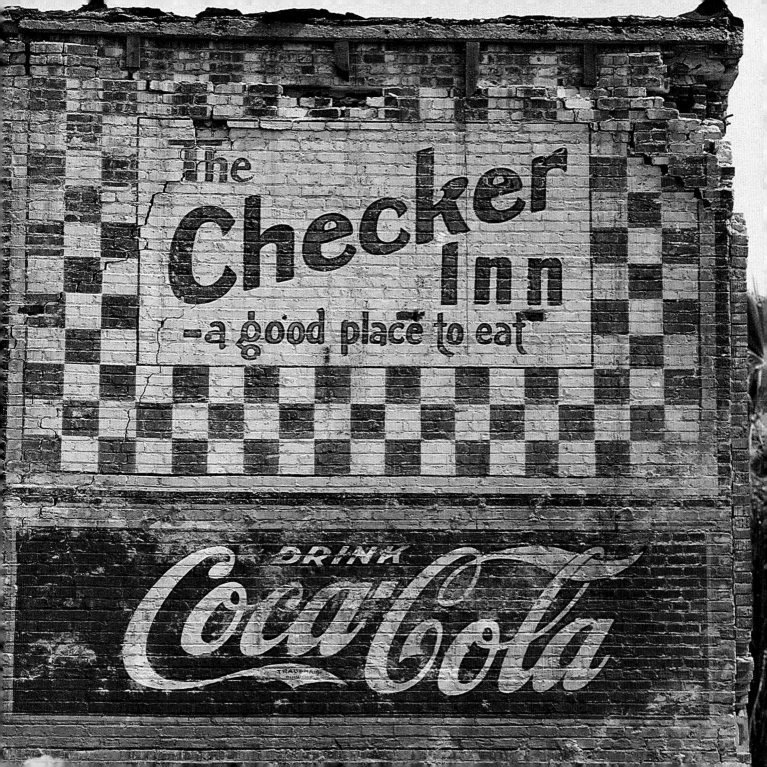

MOSAIC

Inset: *Detail, art deco mosaic entrance-way to the Café Américain, American Hotel. Amsterdam, 1928.*

OSAIC WAS A WIDELY USED TECHNIQUE in the Mediterranean countries. Remnants of ancient Greek and Roman mosaics testify to highly sophisticated civilizations. Oddly enough, many of the decorative mosaic lettered doorsteps of London's Victorian office and bank buildings were lost as a result of the devastating bombing of the Blitz, but this uncovered the remnants of long-buried Roman mosaic pavements.

Some excellent examples of art nouveau gold-on-green mosaic lettering, such as on the Blackfriar Public House, and several mosaic signs on the T. J. Boulting & Sons gas and electrical engineers building, remain in London today. Both are fine specimens of the British arts and crafts movement.

Mosaics have a hard-wearing surface that can be easily cleaned, and thus mosaic lettering was often used to display a shop's name upon its doorstep, or beneath a butcher's shop window.

New York's subway system has made good use of spelling out many of the station names in mosaic. These distinctive signs have recently inspired the signage for a chain of New York–style bagel stores.

The exterior signage to Barcelona's Parc Güell, designed by famed architect Antonio Gaudí, uniquely devised mosaic lettering from tile fragments. Another outstanding use of mosaic in Barcelona is the frontage of the Pastas Alimenticias pastry shop on Las Ramblas.

Mosaic lettering has been used extensively in Amsterdam's American Hotel and Prague's Grand Hotel Europa, as well as in Paris' premier department store, À la Samaritaine, which displays a large, ornate art nouveau mosaic sign on its frontage.

Opposite: *Art nouveau mosaic facade, Pastas Alimenticias pastry shop. Barcelona, 1890s.*

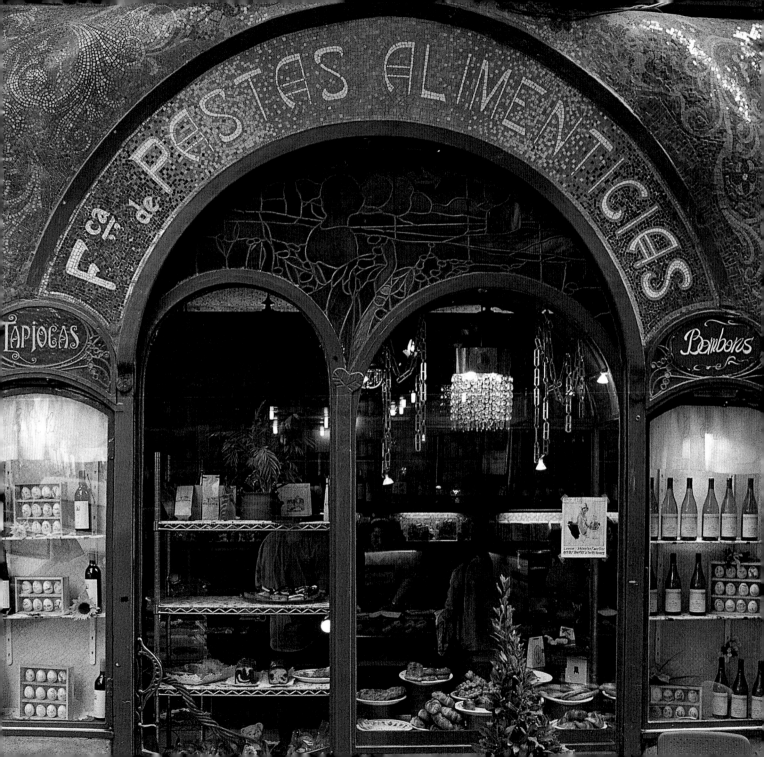

Art nouveau mosaic facade,
A la Samaritaine
department store.
Paris, 1907.

The Bath House
public house.
London, late 19th century.

Dairy mosaic paving.
London, late 19th century.

12

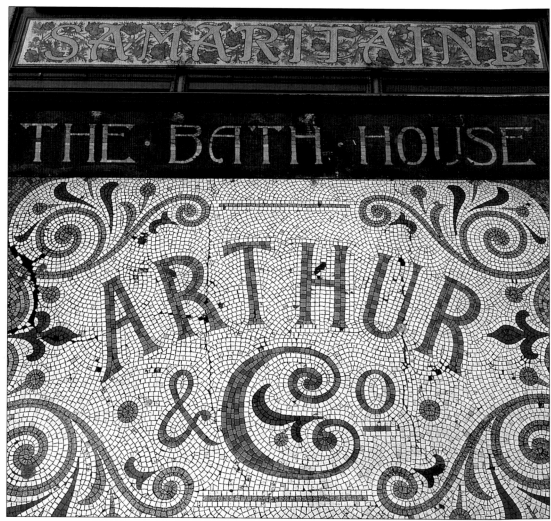

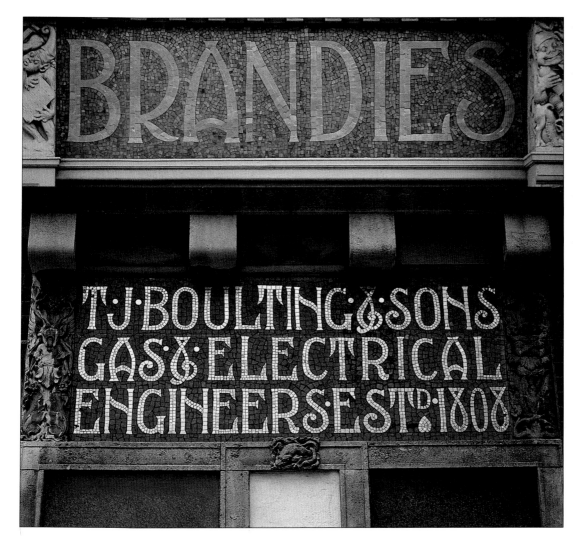

*Arts and crafts movement
mosaic facade,
The Blackfriar public house.
Architect: W. Fuller Clark.
London, 1905.*

*Arts and crafts movement
mosaic facade,
T. J. Boulting & Sons.
Architect: W. Fuller Clark.
London, 1903.*

13

Victorian butcher shop.
London, late 19th century.

Mosaic paving,
letterform based
on the 8th-century
Book of Kells manuscript.
London, late 19th century.

14

Entrance paving,
Jessie Smith & Co.
butcher shop.
Cirencester, England, 1900s.

Opposite: *Mosaic made of tile*
fragments, main facade, Parc Güell.
Architect: Antonio Gaudí.
Barcelona, 1900.

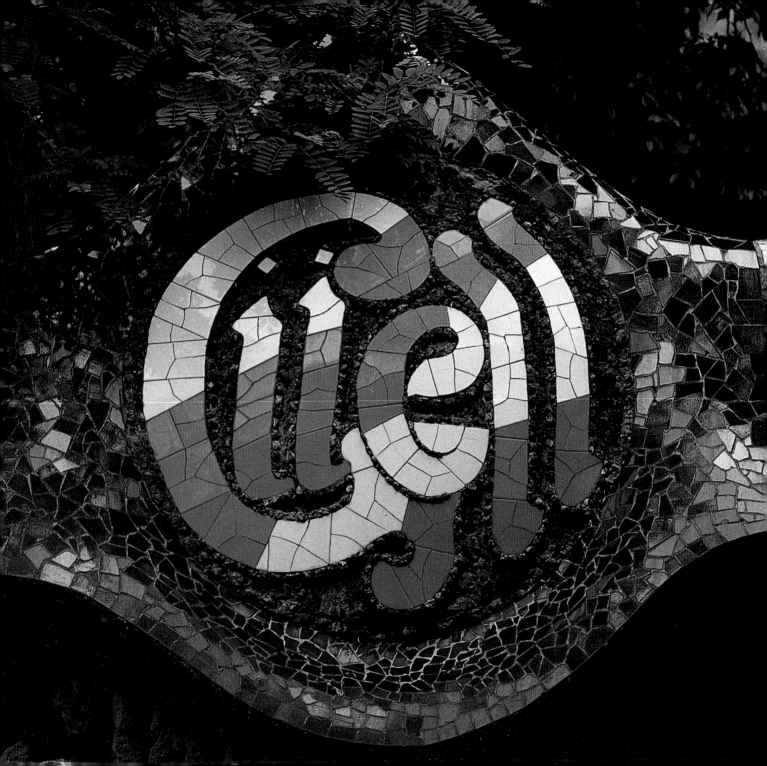

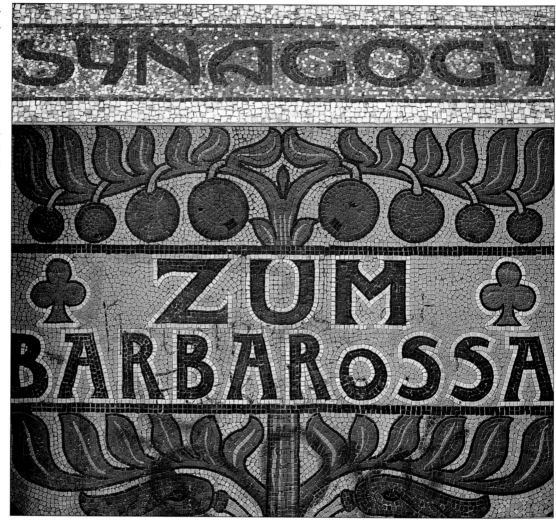

Restaurant facade.
Prague, late 19th century.

Mosaic facade,
Zum Barbarossa cafe.
Architect: G. van Arkel.
Amsterdam, 1897.

16

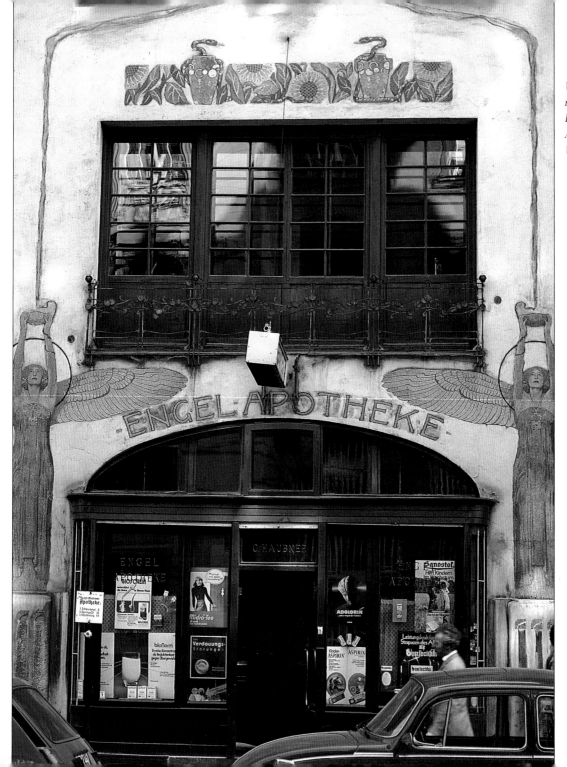

*Vienna Secession
mosaic facade,
Engel Apotheke (pharmacy).
Architect: O. Laske.
Vienna, 1901.*

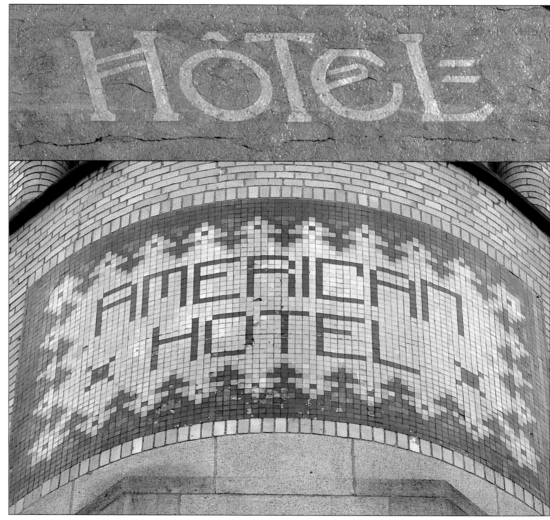

Art nouveau mosaic facade,
Grand Hotel Europa.
Architects:
Bendrich Bendelmayer
and Alois Drak.
Prague, 1903.

Mosaic sign,
American Hotel.
Architect: W. Kromhout.
Amsterdam, 1898–1902.

18

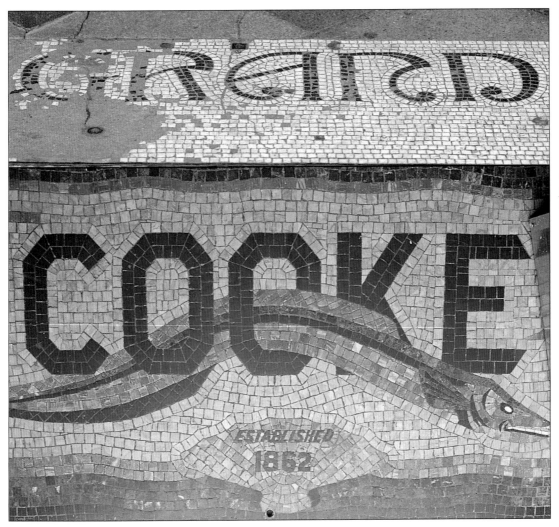

Mosaic paving,
Grand Arcade.
Leeds, England,
late 19th century.

Mosaic paving,
jellied eel shop.
London, 1930s.

METAL

Inset: *Detail, initial "M,"*
Michelin building.
London, 1905.

ETAL, A PLIABLE MATERIAL that, in the hands of a good smith, could be forged, stamped, cut, welded, and molded, or coated with vitreous enamel, became one of the most important materials used during the Industrial Revolution. Iron was wrought into elaborate tracery, examples of which can be seen in Queen Victoria's initials on the iron gates of some of London's royal parks.

Reminders of the royal dynasty of the British Empire can be found in the distinctive cast-iron mailboxes with the initials "GR" (Georgius Rex) inset into the ancient walls of Jerusalem, and in a wall in Koblenz, Germany, both left over from the British occupation. One mailbox in Ramsgate, England, records the short reign of Edward VIII.

During WWII, Prime Minister Winston Churchill, rallying the British people to aid the war effort, ordered that iron railings (not those of historic significance) be melted down for aircraft and ship building. It was later discovered that much of this metal had, in fact, been dumped in the sea. Ironically, the art deco gates of Hitler's concentration camp at Dachau, Germany, bearing the motto *Arbeit macht frei* (Work makes free), remain today.

The art nouveau period brought a proliferation of brass and copper signs, as seen in the lettering of the Blackfriar Public House, London, and the gates of Edward Everard printing works, Bristol. Fine examples of art deco steel lettering are on the canopy of The Savoy Hotel and the Daily Express newspaper building entrance in London, and Thomas Jefferson High School in Los Angeles. Two notable contemporary examples are Ivan Chermayeff's number *nine* for the Solow Building in New York and Takenobu Igarashi's number *three* for Michael Peters & Partners design studio in London.

Opposite top: *Art nouveau*
gallery entrance-way.
Architect: Polívka.
Prague, 1902.
Bottom: *J. J. van Noort School.*
Amsterdam, 1920s

20

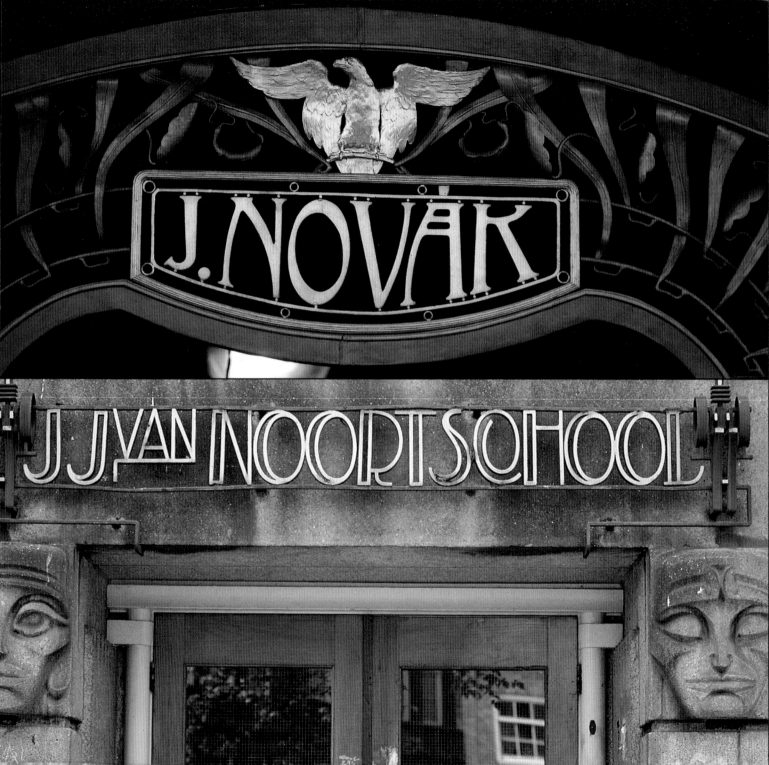

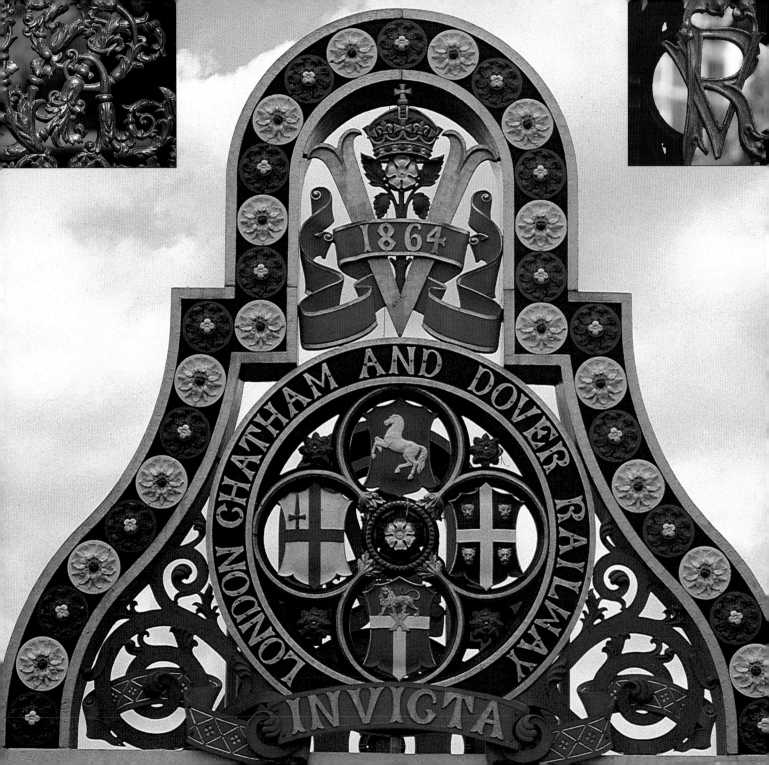

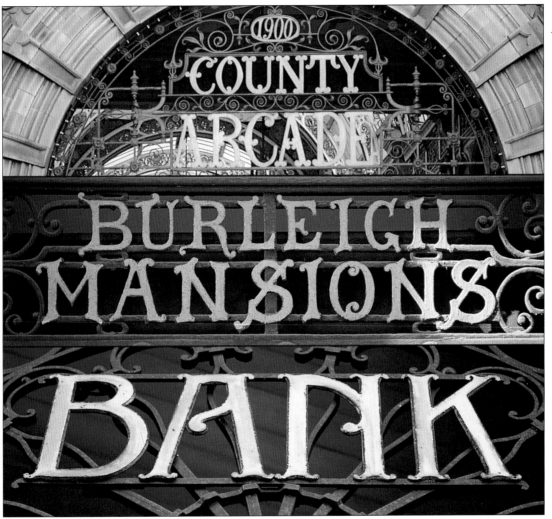

Open latticework
facade, County Arcade.
Leeds, England, 1900.

Apartment facade,
Burleigh Mansions.
London, late 19th century.

23

Bank facade.
London, late 19th century.

Opposite: *Insignia of the
London Chatham and Dover
railway, bridge pier.
London, 1864.*
Inset: *Cast iron gates initial
letters "VR" (Victoria Regina).
London, mid-19th century.*

Victorian "medieval" cast-iron letters, balcony. England, mid-19th century.

Tuscan style cast-iron letters, shop facade. Bath, England, mid-19th century.

24

Cast-iron letters. England, mid-19th century.

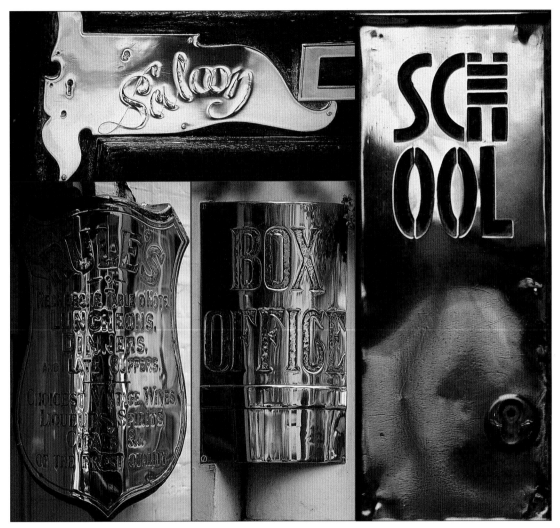

Top left: *Brass door plate, Saloon bar, The Salisbury public house. London, late 19th century.*

Left: *Brass shield, Rules Restaurant. London, late 19th century.*
Center: *Brass sign, theater box office. Bath, England, late 19th century.*
Right: *Brass doorplate, Glasgow School of Art. Architect: Charles Rennie Mackintosh. Glasgow, Scotland, 1897–99.*

Apartment
building nameplate.
London, late 19th century.

Facade, Harrods
department store.
Architect:
C. W. Stevens & Hunt.
London, 1894.

Victorian "medieval" brass
letters, detail,
public house window sill.
London, mid-19th century.

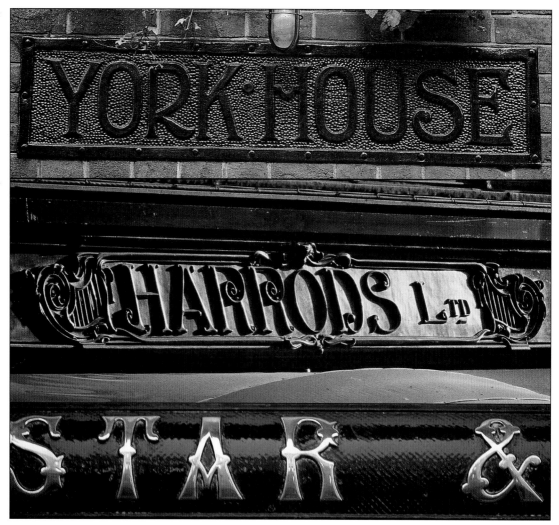

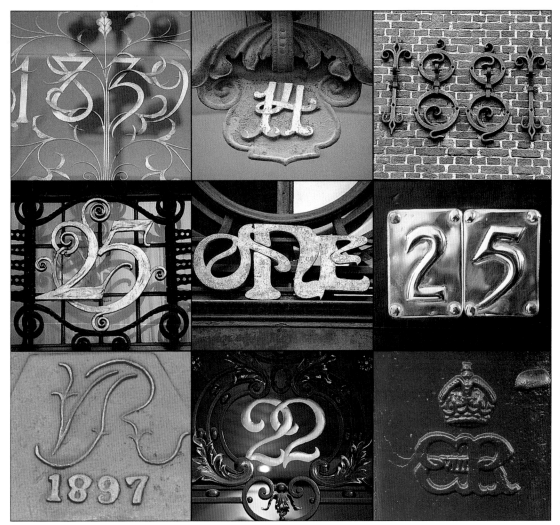

Left: *Gilded wrought metal fanlight. Amsterdam, 1839.*
Center: *House number. Copenhagen, late 19th century.*
Right: *Wrought iron wall anchor. Brussels, 1881.*

Left: *Shop number. Amsterdam, late 19th century.*
Center: *Metal door number, Inveresk House. London, 1906.*
Right: *Brass studio door number, Glasgow School of Art. Glasgow, Scotland, 1897–99.*

Left: *Initials "VR" (Victoria Regina), mailbox. Albany, Western Australia, 1897.*
Center: *House number. London, late 19th century.*
Right: *Initials "ER VIII," (Edwardus Rex), mailbox. Ramsgate, England, 1936.*

Copper sign on entrance gates to Simpson's Restaurant. London, 1903.

Left: *Brass sign, weather-proof clothing store. Architect: Waddington. London, 1900s.*
Right: *Art nouveau copper plaque. London, 1905.*

28

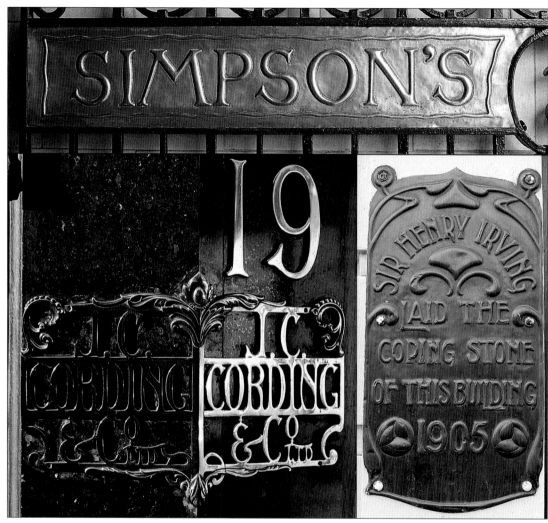

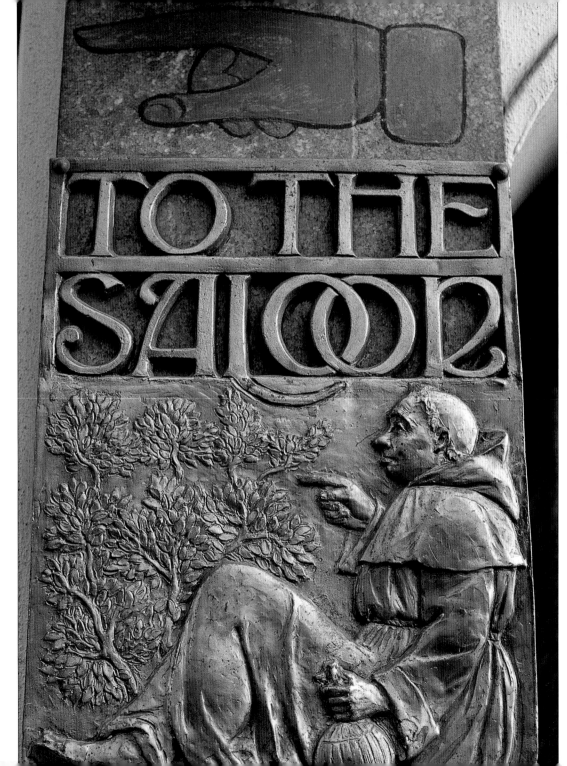

TO THE
SALOON

Arts and crafts movement copper entry sign, The Blackfriar public house. Architect: W. Fuller Clark. London, 1905.

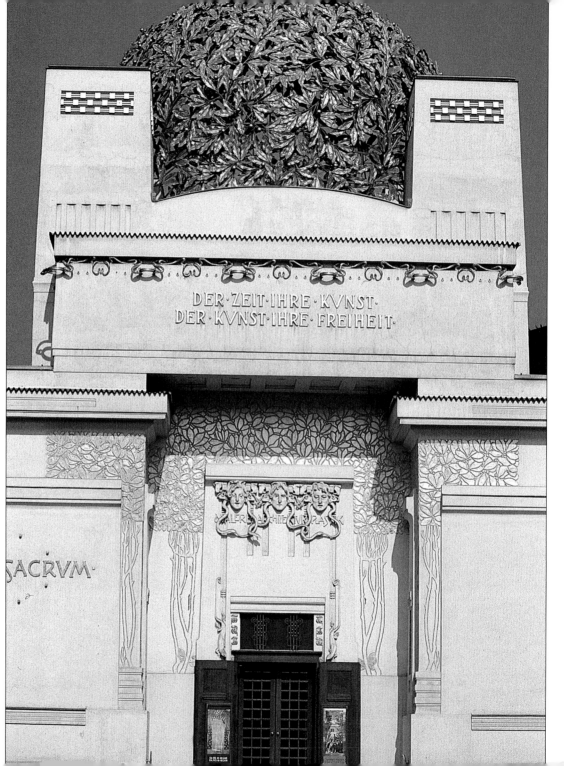

Secession Pavilion,
"The Gilded Cabbage."
Architect:
Joseph Maria Olbrich.
Vienna, 1897.

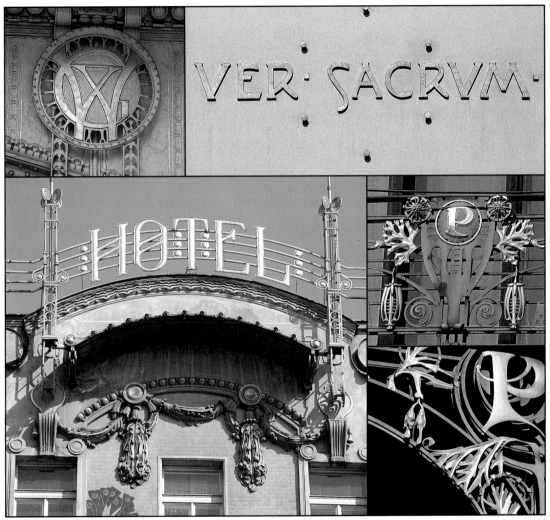

Left: *Initials "GW,"*
pedestrian bridge.
Vienna, late 19th century.
Right: *Gilded lettering*
on stone, "Ver sacrum"
(sacred spring),
Secession House Pavilion.
Vienna, 1897.

Left: *Gilded sign,*
Hotel Europa.
Prague, 1902.
Right: *Initial letter "P"*
on balcony.
Prague, late 19th century.

Right: *Initial letter "P"*
on latticework,
Obecní dům Municipal
House Theater.
Prague, 1903.

Left: *Brass mailbox,*
Oviatt Building.
Architects: Walker & Eisen.
Los Angeles, 1927.
Right: *Pharmacy lattice*
metal hanging sign.
Rouen, France, 1930s.

Pharmacy facade.
Barcelona, 1930s.

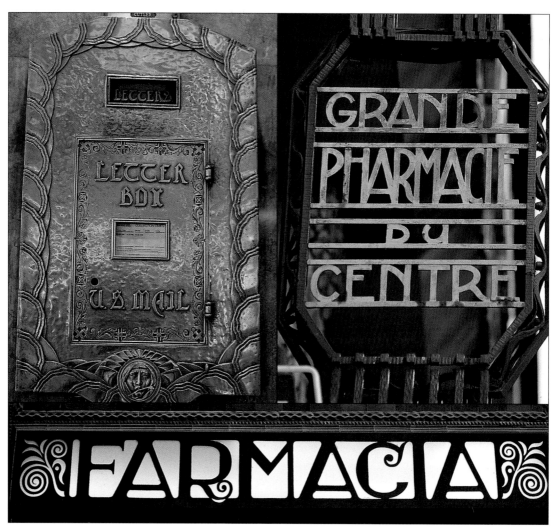

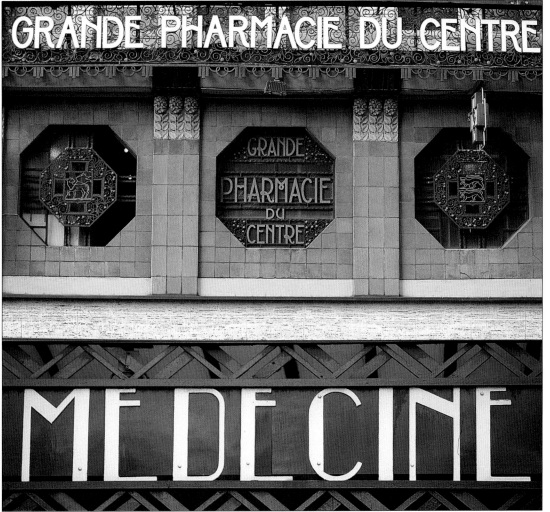

Pharmacy facade.
Rouen, France, 1930s.

Metal sign, pharmacy.
Paris, 1930s.

Left: *Art deco metal facade sign, Daily Express newspaper building. Architects: Ellis and Clarke. London, 1931.*
Top: *Entry canopy, The Savoy Hotel. Designer: Basil Ionides. London, 1929.*

Bottom: *Simpson Piccadilly, clothing store. London, 1935.*

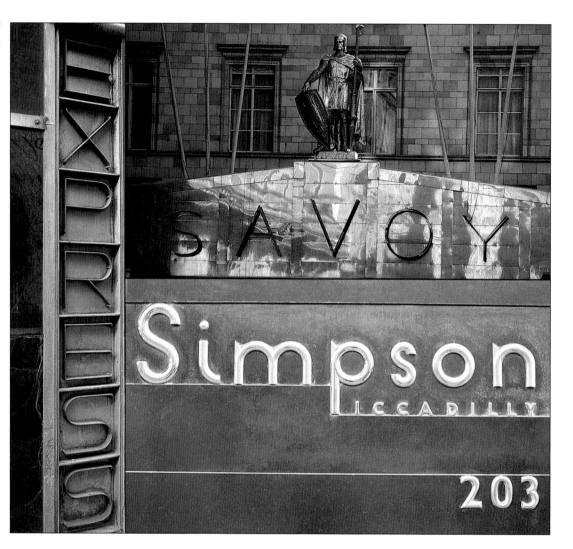

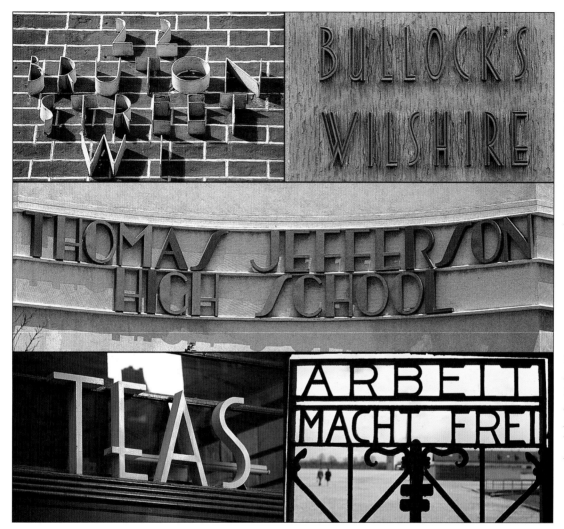

Art deco letterforms:
Left: *House number.*
London, 1930s.
Right: *Bullock's Wilshire*
department store.
Architects: John and
Donald Parkinson.
Los Angeles, 1928.

Thomas Jefferson
High School.
Architect: Stiles O. Clements.
Los Angeles, 1936.

Left: *Restaurant facade.*
London, 1930s.
Right: *Wrought iron*
concentration camp gates.
Motto reads
"Work makes free."
Dachau, Germany, 1933.

Tuschinski Theater.
Designer:
Heyman Louis de Jong.
Amsterdam, 1918–21.

Cushioned sheet metal,
Heineken brewery.
Amsterdam, 1930s.

Building facade, Hays Wharf.
Architect: H. S. Goodhart.
Designer:
Frank Dobson Rendel.
London, 1930.

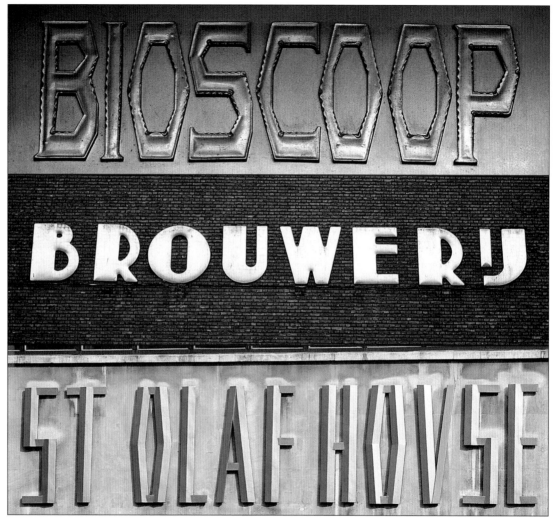

Wiener Werkstätte period bookshop facade. Architect: Adolf Loos. Vienna, 1912.

Brass door sign, art gallery. Barcelona, 1930s.

Brass sign, patisserie. Barcelona, 1930s.

Art deco letterforms:
Chrome facade,
menswear shop.
London, 1930s.

Cut sheet-metal facade.
Brussels, 1930s.

38

Restaurant facade.
London, 1930s.

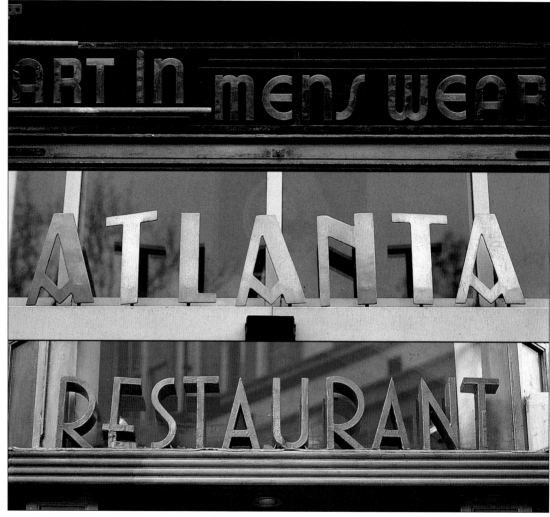

Opposite left: *Street number, 15,000 pounds*
of stoved red sheet steel, Solow Building.
Designer: Ivan Chermayeff.
New York City, 1981.
Right: *Stainless steel building number,*
Michael Peters & Partners design studio.
Designer: Takenobu Igarashi.
London, 1983.

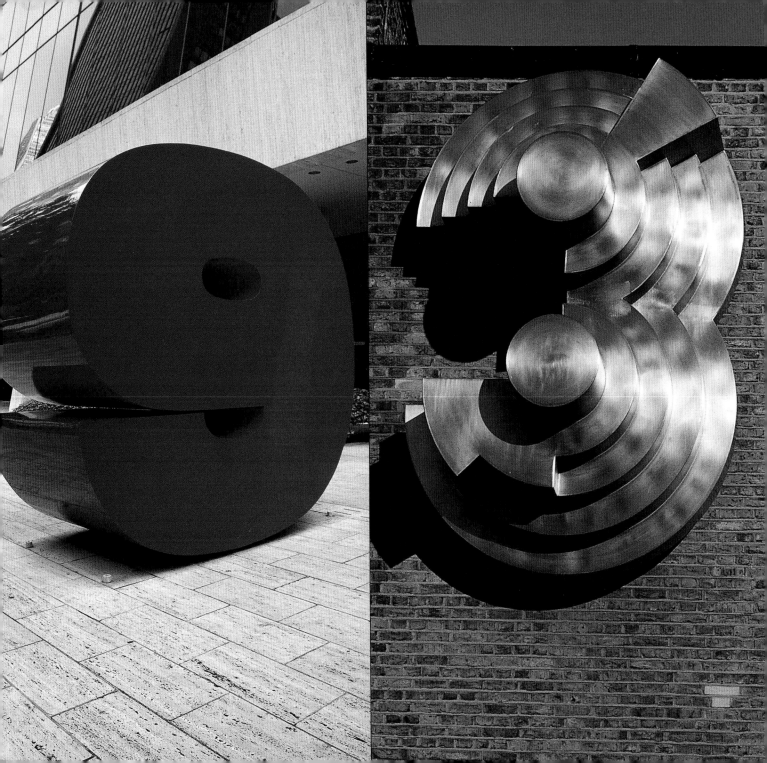

ILES DATE BACK to the early Assyrians and Babylonians, and many of their pieces retain their color and smooth surface to this day. Tiles were not in general use in Europe until the second half of the twelfth century, when they were employed as the decoration for cathedrals and churches.

Tiles came into their own during the nineteenth century and provided an ideal hygienic surface that could easily be cleaned in dairies and butcher shops, hospitals and subway stations.

Daniel Defoe, the eighteenth century novelist and journalist, referred to London's West End as "a new world of brick and tile." Much of this world made up of pressed clay was reduced to dust during WWII, yet there remain a few outstanding examples, namely Bibendum, the former Michelin Tyre building; the rich oxblood-red tiles in the Metropolitan Railway stations; the St. Pancras Public Baths; the magnificent inscription in the Gamble Room in the Victoria & Albert Museum; the unusual Victorian letter forms in gilded terra-cotta on the *Eglise Protestante* (French church); the enormous tiled lettered surface of the Royal Hospital for Children; and G. F. Watts' unique hand-lettered Doulton tile memorial plaques to heroes of unusual disasters at Postman's Park.

William Morris referred to the craft of tile design as "one of the lesser arts of life." Ironically, in 1901, five years after his death, he was memorialized in tile on the facade of the former printing works of Edward Everard in Bristol. Art historian Nikolaus Pevsner described the building as "the wildest art nouveau." Equally outstanding specimens of tiled lettering are to be found all over Europe, notably at the Royal Arcade in Norwich, the Hotel Metropole in Moscow, and the Farmácia on Las Ramblas, Barcelona.

Opposite: *Art deco
pharmacy facade.
Barcelona, 1930s.*

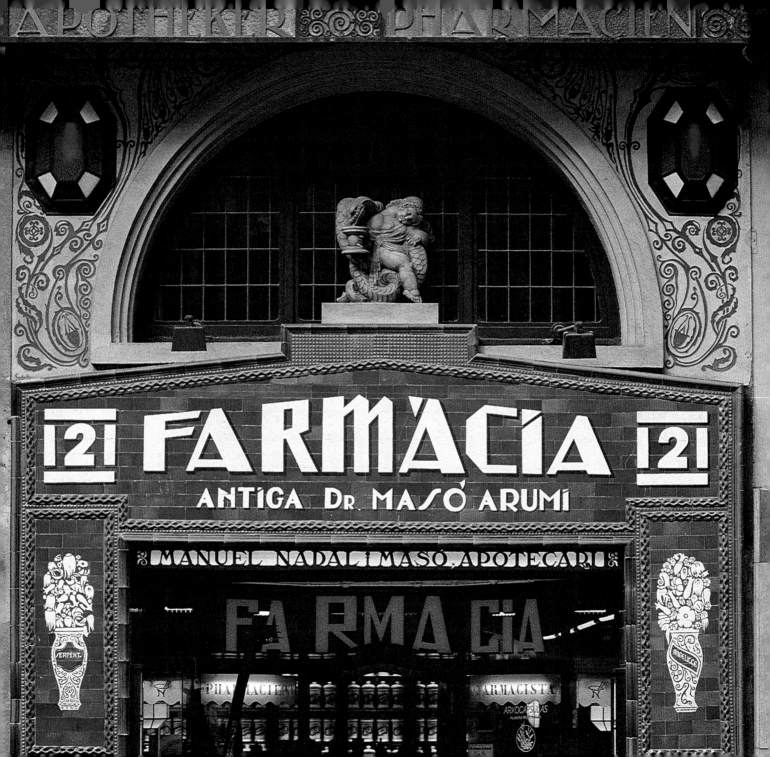

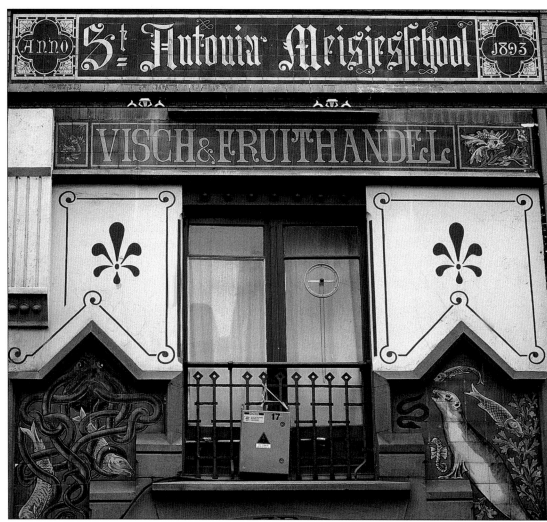

Facade,
St. Antonia School.
Amsterdam, 1893.

Tiled facade,
fish merchant.
Amsterdam,
late 19th century.

42

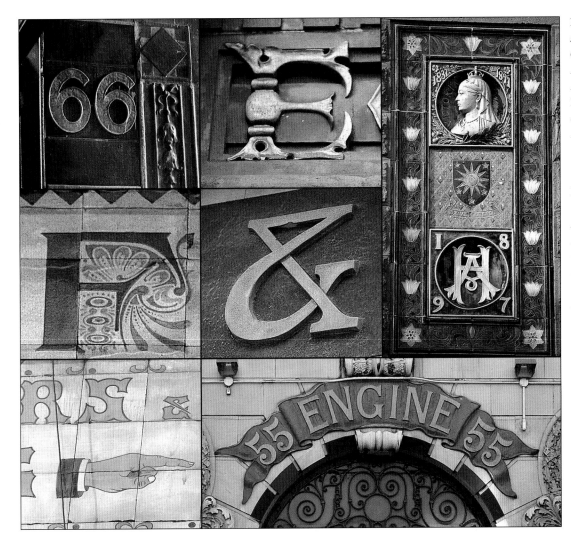

Left: *66th Street subway sign. New York City.*
Center: *Initial letter "E," French Protestant church. London, 1893.*
Right: *Polychrome tiles commemorative plaque. Inverness, Scotland, 1897.*

Left: *Detail, tiles, Cafe Restaurant. Amsterdam, late 19th century.*
Center: *Ampersand, ceramic facade, Chard & Sons, butchers. London, 1890.*

Left: *Detail, shop facade. Madrid, late 19th century.*
Right: *55 Engine Company. New York City, late 19th century.*

43

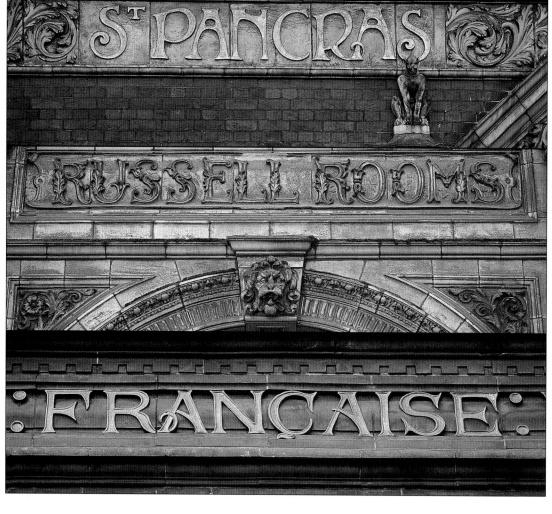

Gilded terra-cotta tiles, St. Pancras Public Baths. London, 1898.

Terra-cotta and red brick entry to Gothic Revival building, Russell Hotel. Architect: FitzRoy Doll. London, 1898.

44

Gilded terra-cotta tiles facade, French Protestant church. London, 1893.

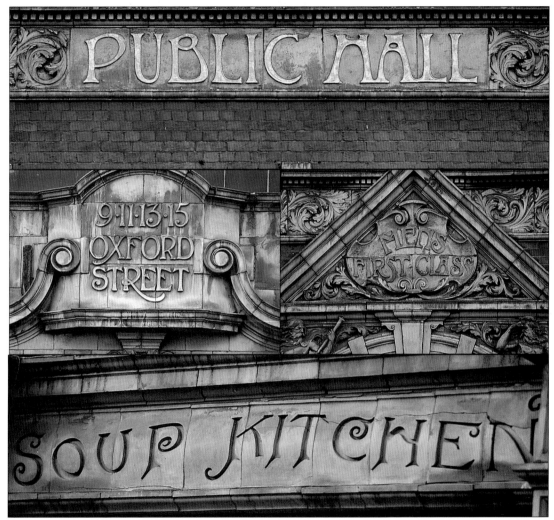

Gilded terra-cotta tiles, St. Pancras public baths. London, 1898.

Left: *Apartment facade. London, late 19th century.* **Right:** *St. Pancras public baths. London, 1898.*

45

Incised terra-cotta tiles facade, "Soup Kitchen for the Jewish Poor." London, 1902.

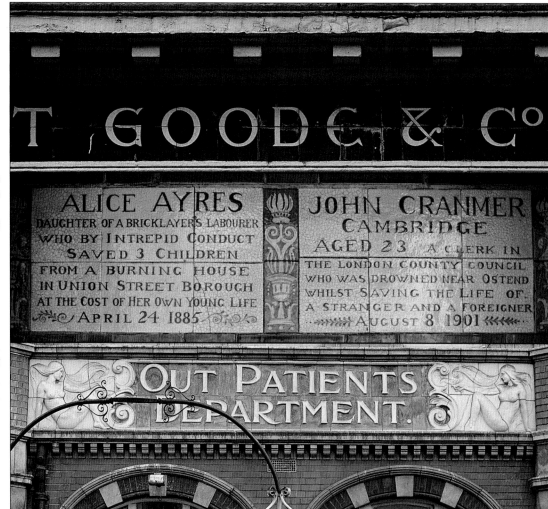

Shop facade.
London, 1876.

Two of 53 polychrome
ceramic Doulton tile
memorial tablets,
The Watts Memorial
Postman's Park.
London, 1900.

Glazed tile facade,
The Royal Waterloo Hospital
for Children and Women.
London, 1903.

T. GOODE & Cº

ALICE AYRES
DAUGHTER OF A BRICKLAYER'S LABOURER
WHO BY INTREPID CONDUCT
SAVED 3 CHILDREN
FROM A BURNING HOUSE
IN UNION STREET BOROUGH
AT THE COST OF HER OWN YOUNG LIFE
APRIL 24 1885

JOHN CRANMER
CAMBRIDGE
AGED 23 A CLERK IN
THE LONDON COUNTY COUNCIL
WHO WAS DROWNED NEAR OSTEND
WHILST SAVING THE LIFE OF
A STRANGER AND A FOREIGNER
AUGUST 8 1901

OUT PATIENTS
DEPARTMENT.

Opposite: *The "South Kensington Alphabet."*
Inscription reads: "There is nothing better
for a man than that he should eat and drink,
and that he should make his soul
good in his labour XYZ."
Architects: Godfrey Sykes and James Gamble.
Tiles by Minton.
The Gamble Room, Victoria & Albert Museum.
London, 1868.

48

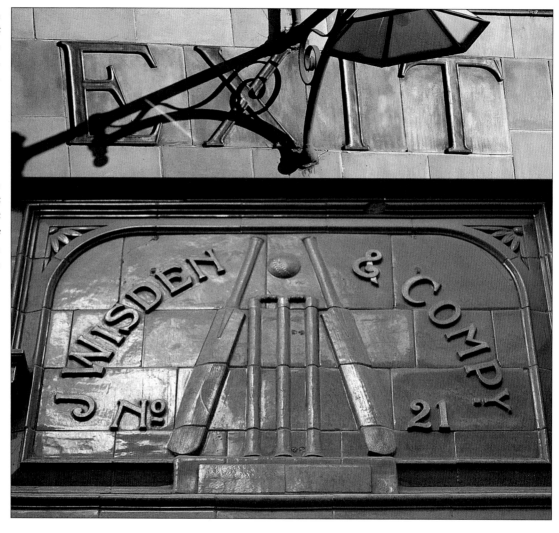

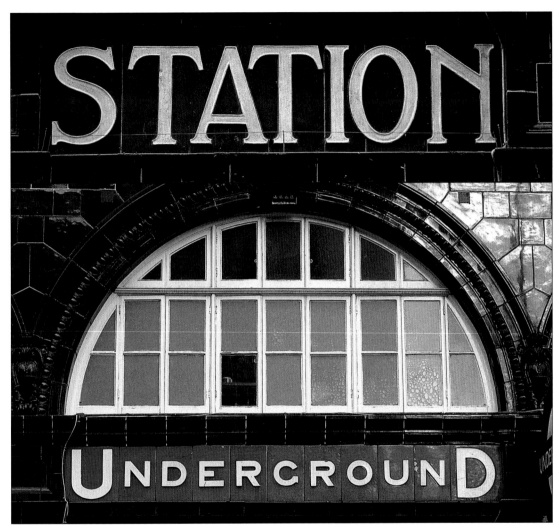

Oxblood-red tiles,
Underground station.
Architect: Charles T. Yerkes.
London, 1900s.

London Underground
logotype in "Railway"
type designed by
Edward Johnston.
London, 1916.

49

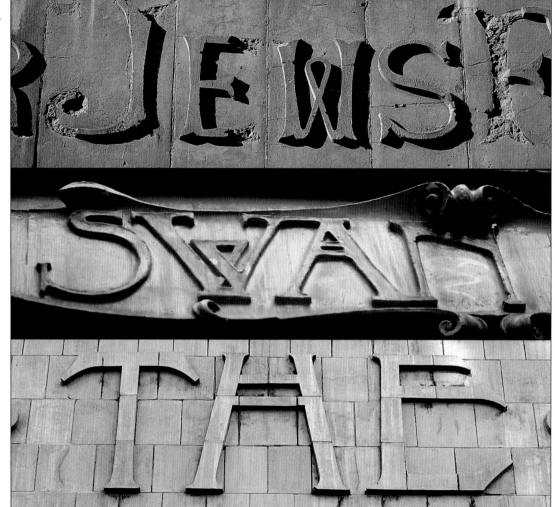

Detail, terra-cotta facade,
Westminster
Jews Free School.
Architect:
Hyman Henry Collins.
London, 1883.

Art nouveau glazed tiles,
The Swan public house.
London, late 19th century.

50

Detail, side wall,
The Coliseum Theatre.
Architect: Frank Matcham.
London, 1904.

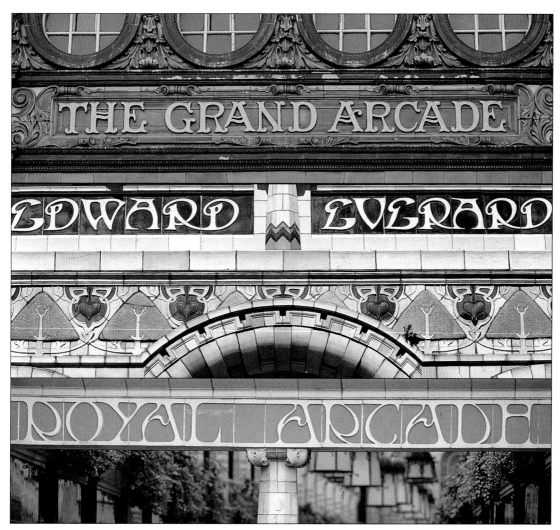

Polychrome tiles,
The Grand Arcade.
Leeds, England, 1900.

Detail, art nouveau facade,
Edward Everard's
printing shop.
Doulton Carrara–ware tiles.
Lettering design:
Edward Everard.
Bristol, England, 1901.

51

Detail, art nouveau
entrance, Royal Arcade.
Architect: George Skipper.
Norwich, England, 1898.

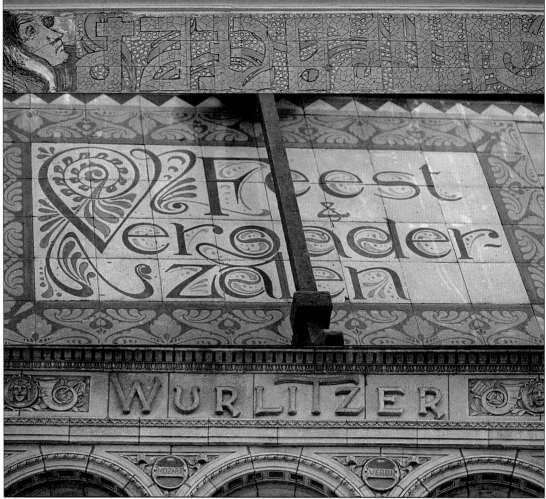

Tiled facade,
Hotel Metropole.
Architects:
W. Walcott and A. Erikhson.
Moscow, 1899.

Building facade.
Amsterdam,
late 19th century.

Facade, Wurlitzer organ
company. Inset plaques
pay tribute to
Mozart and Verdi.
Los Angeles,
late 19th century.

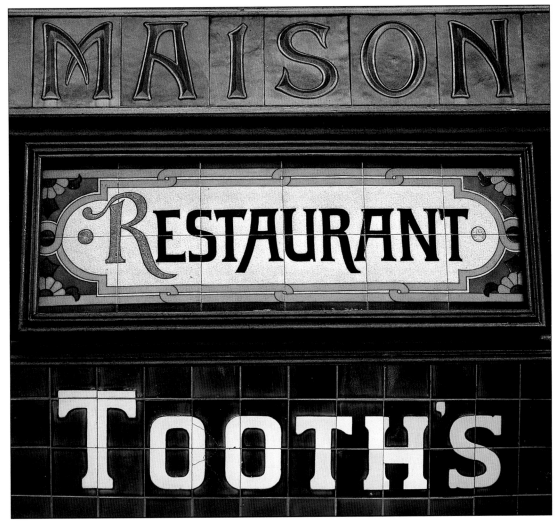

Detail, shop facade.
Brussels, late 19th century.

Restaurant facade.
Paris, late 19th century.

53

Tooth's public house.
Sydney, Australia,
late 19th century.

*Bank building facade.
Amsterdam,
late 19th century.*

54

*Facade, Cafe.
Amsterdam,
late 19th century.*

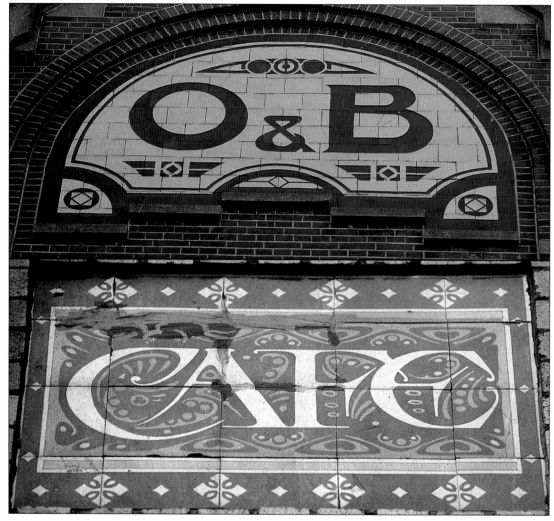

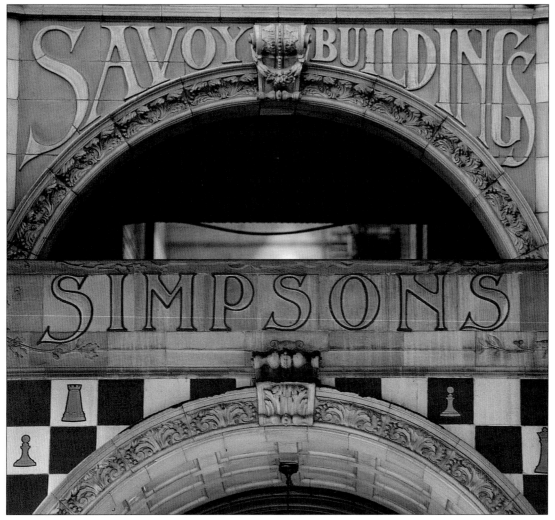

Tiled archway,
Savoy Buildings.
London, 1903.

55

Facade,
Simpson's Restaurant.
London, 1903.

Left: *Art nouveau initial "M," Michelin Building. London, 1905.*
Right: *Helms Bakery building. Architect: E.L. Bruner. Los Angeles, 1930.*

Burmantoft's "Marmo" facing tiles, Bibendum Michelin building. Architect: Edouard Montaut. London, 1905.

56

Left and right: *Tiled facade, coffee merchant. Amsterdam, late 19th century.*

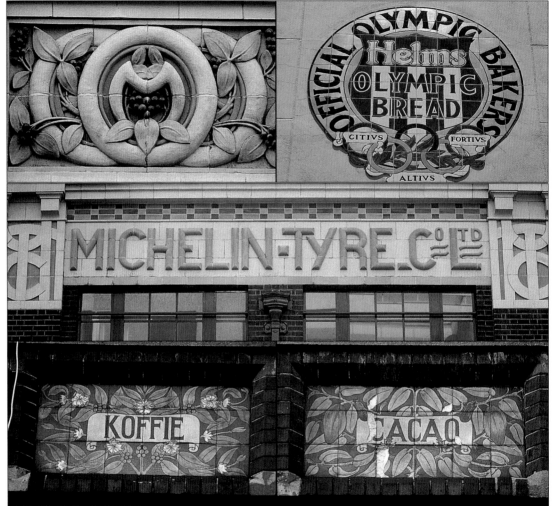

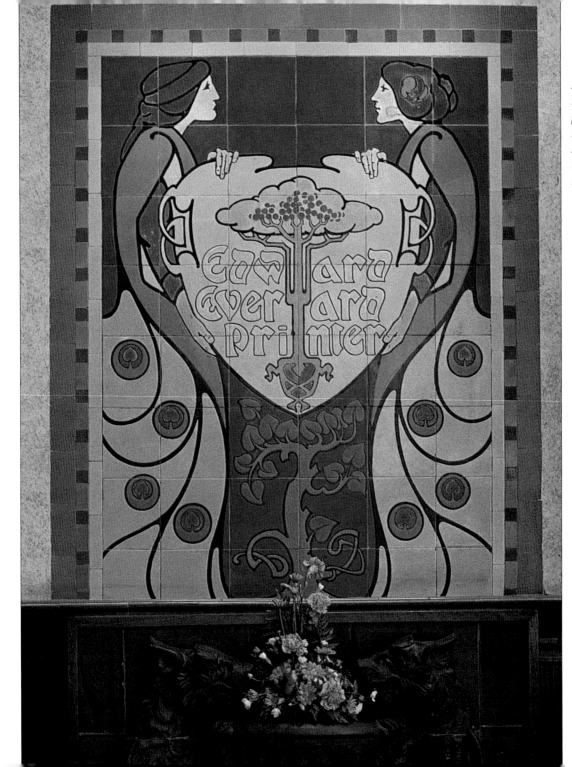

Art nouveau tiled fireplace,
Edward Everard's
printing shop.
Doulton Carrara–ware tiles.
Architect: Henry Williams.
Tile decoration: W. J. Neatby.
Bristol, England, 1901.

57

Details, facade of "Kola Champagne" bottling plant. San Juan, Puerto Rico, 1920s.

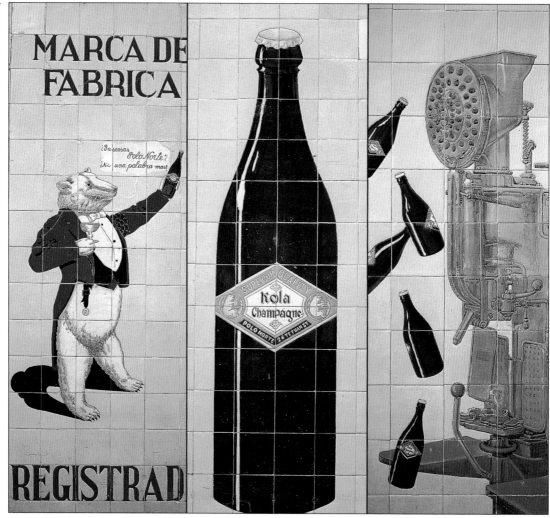

Opposite: *American Legion building. Architect: Eugene Weston, Jr. Los Angeles, 1929.*

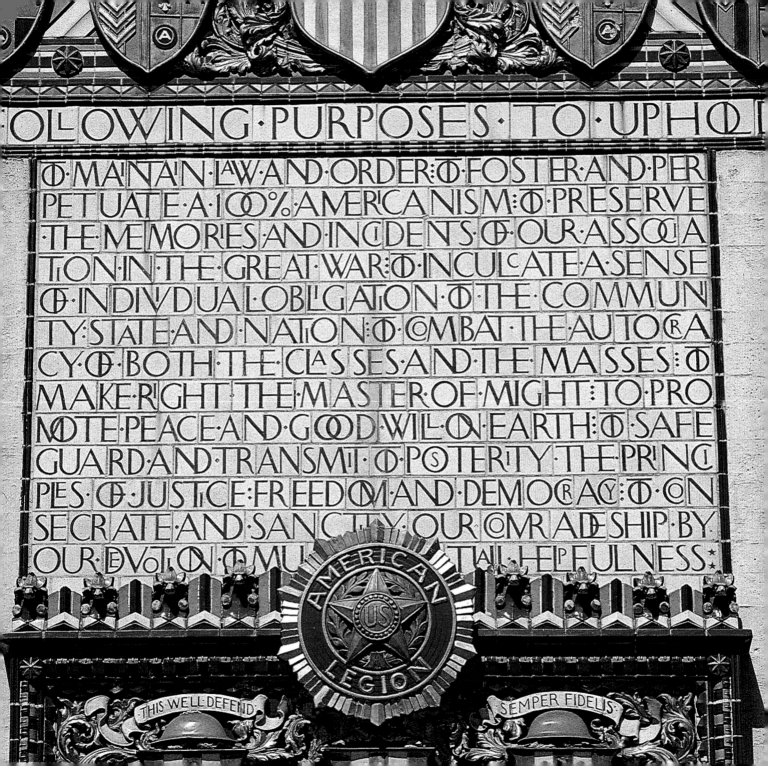

OLLOWING · PURPOSES · TO · UPHOLD

TO MAINTAIN LAW AND ORDER : TO FOSTER AND PER
PETUATE A 100% AMERICANISM : TO PRESERVE
THE MEMORIES AND INCIDENTS OF OUR ASSOCIA
TION IN THE GREAT WAR : TO INCULCATE A SENSE
OF INDIVIDUAL OBLIGATION TO THE COMMUNI
TY STATE AND NATION : TO COMBAT THE AUTOCRA
CY OF BOTH THE CLASSES AND THE MASSES : TO
MAKE RIGHT THE MASTER OF MIGHT : TO PRO
MOTE PEACE AND GOOD WILL ON EARTH : TO SAFE
GUARD AND TRANSMIT TO POSTERITY THE PRINCI
PLES OF JUSTICE FREEDOM AND DEMOCRACY : TO CON
SECRATE AND SANCTIFY OUR COMRADESHIP BY
OUR DEVOTION TO MUTUAL HELPFULNESS ✦

AMERICAN
US
LEGION

THIS WE'LL DEFEND

SEMPER FIDELIS

Tiled facade,
Cafe Restaurant.
American Hotel.
Amsterdam, 1898–1902.

Facade, life insurance
company building.
Architect: A. L. van Gendt.
Amsterdam, 1899.

Detail, facade.
Amsterdam,
late 19th century.

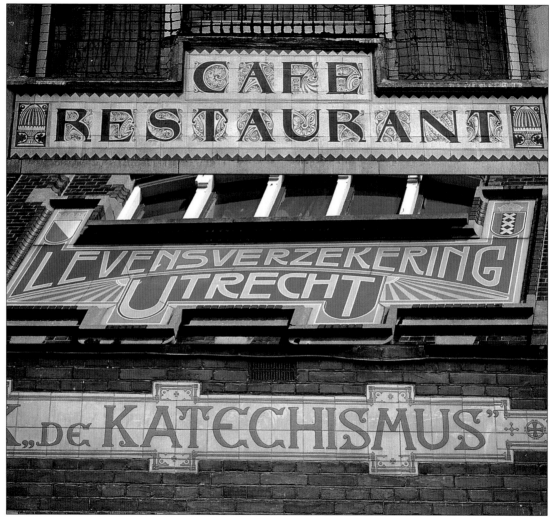

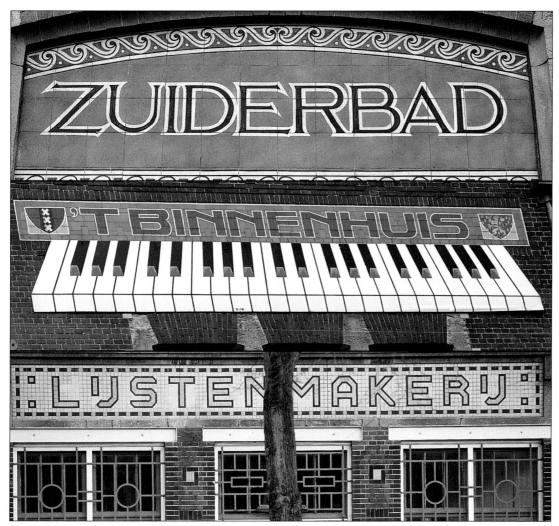

Tiled facade.
Built as a cycling school
in 1898, converted to a
swimming pool in 1912.
Architect: J. Ingenohl.
Amsterdam.

Tiled facade, piano shop.
Architects:
Stall & Kropholler.
Amsterdam, 1907.

61

Tiled facade, shop.
Amsterdam, 1930s.

LASS BECAME A POPULAR MEDIUM for lettered signs in the middle of the nineteenth century, and it was used in a variety of techniques: stained or leaded, cut, etched, gilded, embossed, sandblasted, and, in the 1900s, with neon. Glass was found to be an efficient and enduring surface that was easier to clean than such materials as brass, which needed constant polishing. The Victorians demonstrated glass' versatility at London's Great Exhibition of 1851, which brought about a myriad of uses. The finer examples can still be found on the facades of pharmacies and public houses in the British Isles, their ornate Victorian lettering cleverly gilded by signwriters working in reverse on the back of the plate glass.

The ancient craft of stained glass, as found in most of the medieval cathedrals of Europe, was sustained through to the art deco period. A proliferation of this colorful lettering can be found on restaurant facades in Brussels, and on many European theaters and cinemas, a particularly fine example being the Theater Passage in The Hague, Netherlands. Small boarding houses in British seaside resorts often displayed their quaint names in leaded glass above the front door.

Neon was introduced in 1910 in Paris by Georges Claude, and soon became a universally popular medium for signage. The world's largest advertising billboard was the neon sign produced for Citroen, which read almost from top to bottom on Paris's Eiffel Tower. Neon made its debut in Los Angeles in 1923, and it captured the glamor of the art deco period. However, the use of neon signs was put on hold during the black-out years of WWII. It was widely used for cinema facades. Today, landmark city centers such as New York's Times Square, London's Piccadilly Circus, Tokyo's Ginza, and Las Vegas's "Glitter Gulch" have become meccas of neon.

Opposite: *Victorian tobacconist shop front. London, late 19th century.*

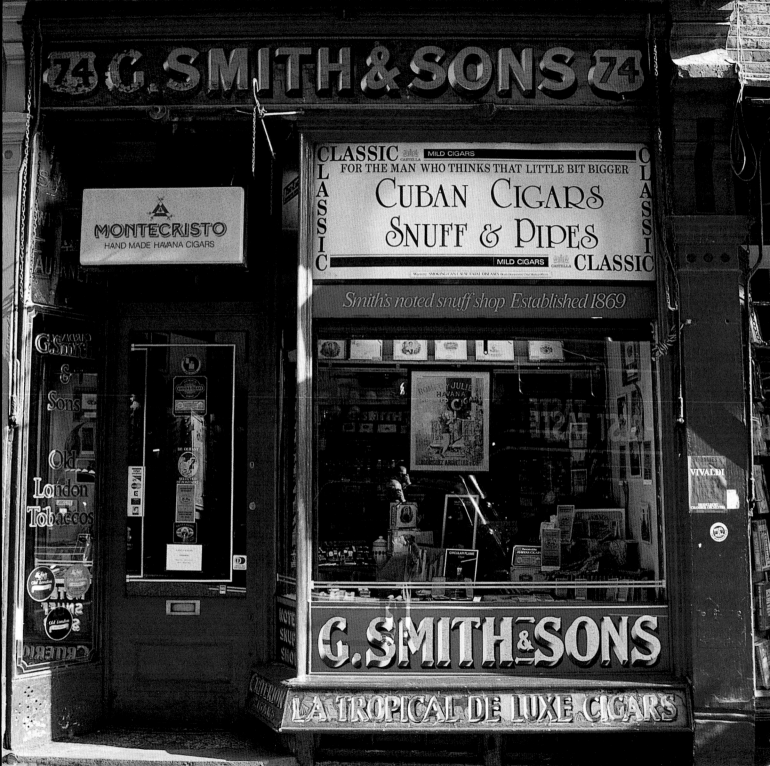

Tuscan letterforms:
Facade, shop.
Brussels, late 19th century.

Left: *Butcher shop fanlight.*
Cirencester, England, 1890s.
Right: *Gilded shop window.*
Vienna, late 19th century.

Detail, shop front.
Vienna, late 19th century.

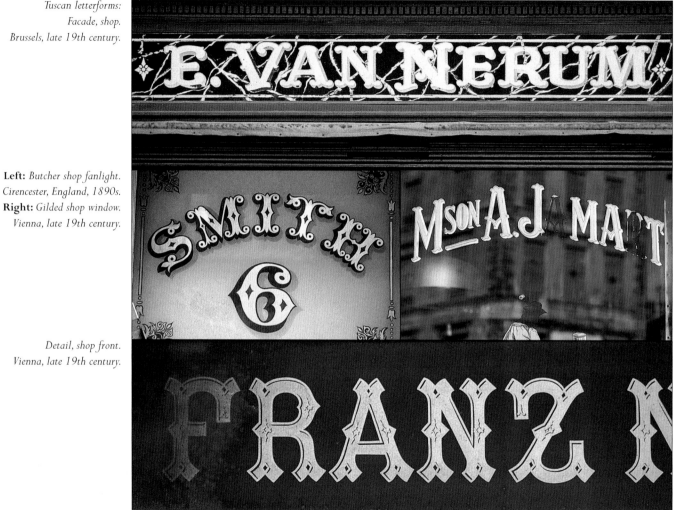

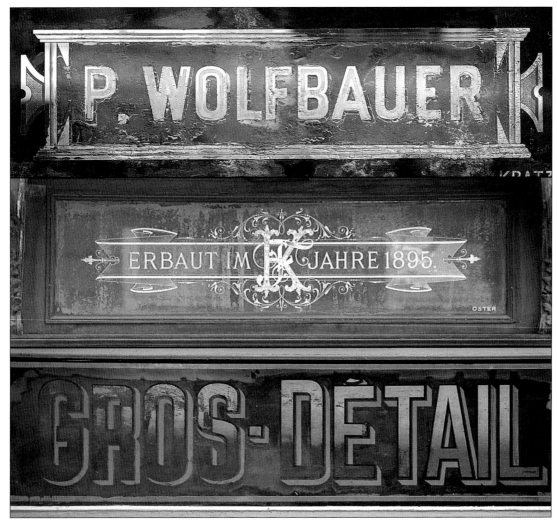

Gilded signs
painted on glass.
Vienna, 1890s.

Gilded sign painted
on glass fanlight.
Vienna, 1895.

Shaded sans serif letters,
facade, shop.
Brussels, 1920s.

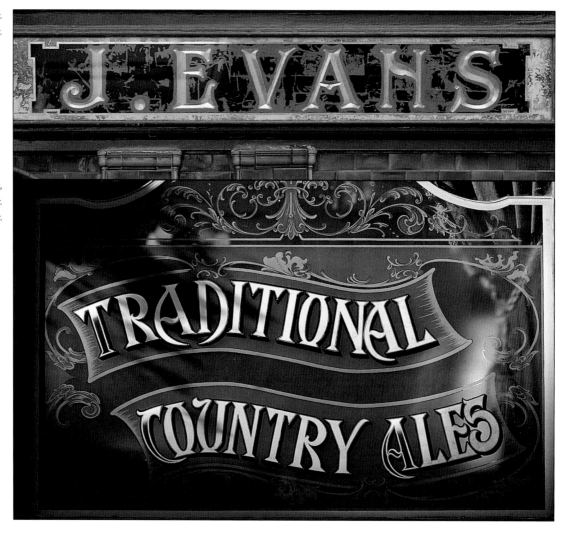

Facade, dairy.
London, late 19th century.

Etched glass,
public house window.
London, late 19th century.

66

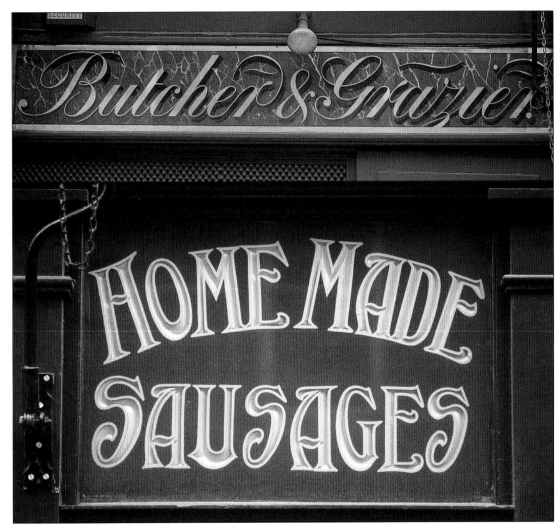

Gilded script,
butcher shop facade.
London, 1900s.

Art nouveau facade,
Jessie Smith & Co.
butcher shop.
Cirencester, England, 1890s.

Dimensional gilded
V-cut incised letters,
shop facade.
London, 1900s.

Dimensional lettering,
detail, facade,
Bert's Fish and Chips shop.
London, 1920s.

"Old English" style lettering,
facade, laundry.
London, 1920s.

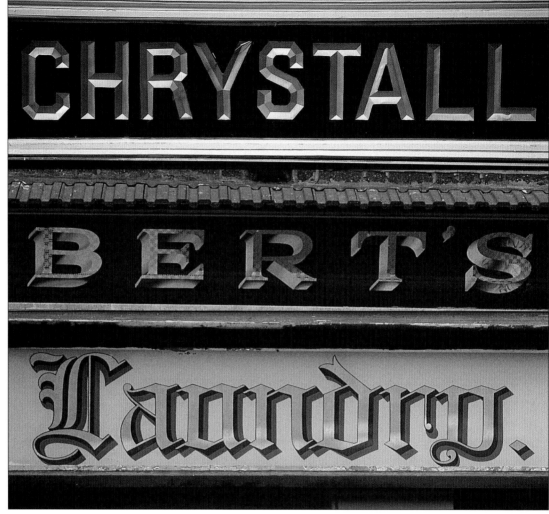

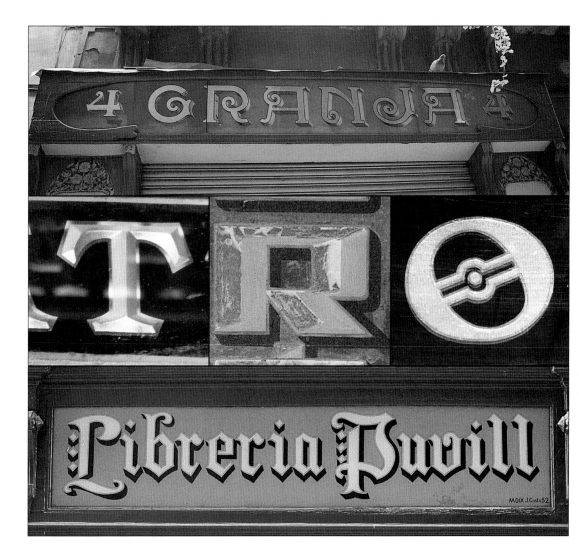

Shop facade.
Barcelona,
late 19th century.

Left: Detail,
wigmaker's shop facade.
Bath, England,
mid-19th century.
Center: Glass painted sign.
Budapest, 1930s.
Right: Detail, hairdresser.
London, late 19th century.

Book shop facade.
Barcelona, late 19th century.

70

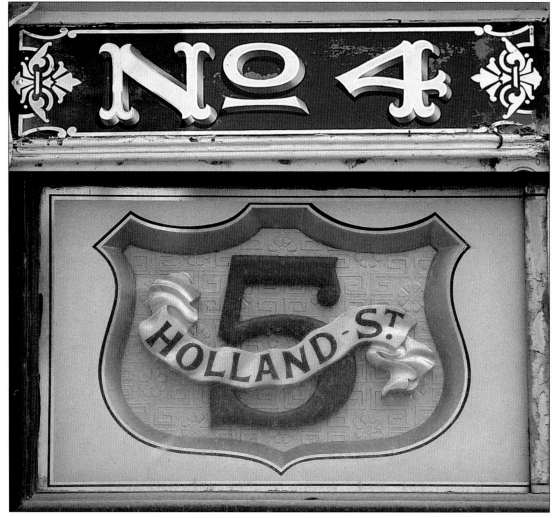

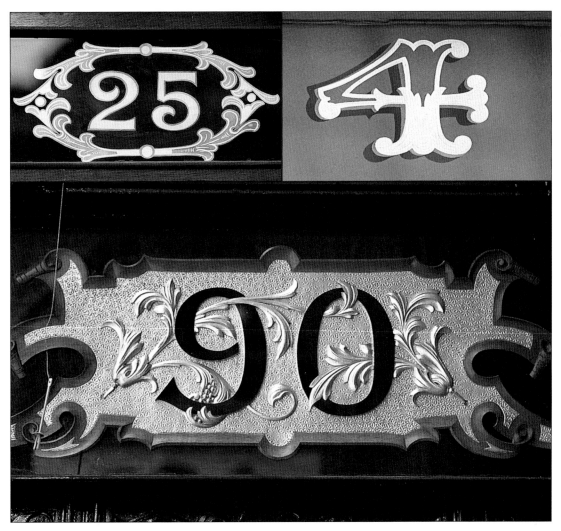

Gilded and etched glass numerals, public houses. London, late 19th century.

*Cut-glass Tuscan lettering,
public house windows.
London, late 19th century.*

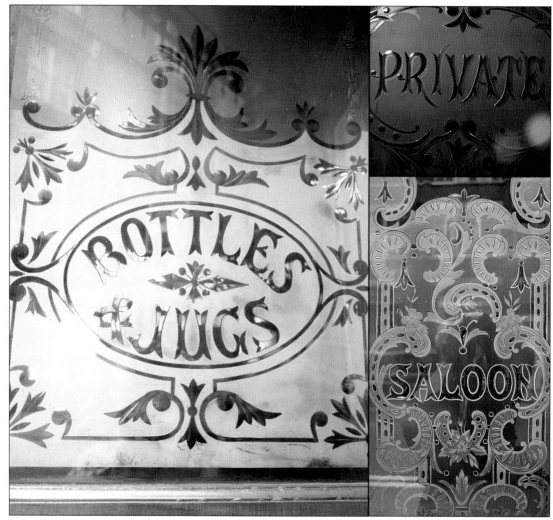

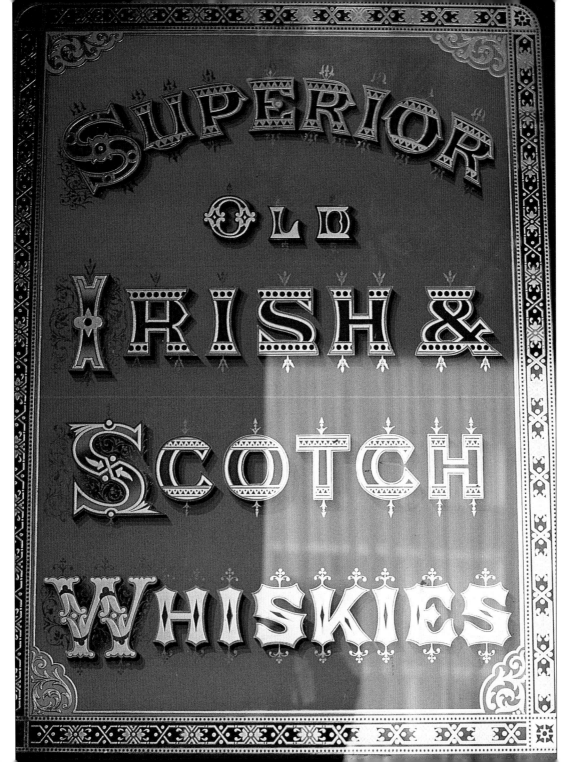

Victorian gilded and etched mirror, Balmoral Castle public house. London, 1870s.

Victorian gilded and etched glass public house facades. London, late 19th century.

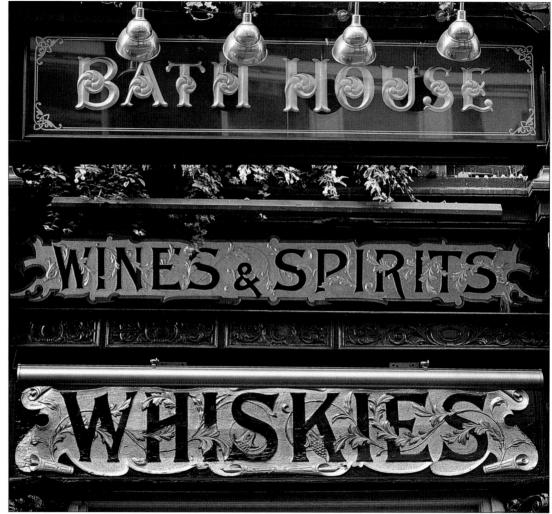

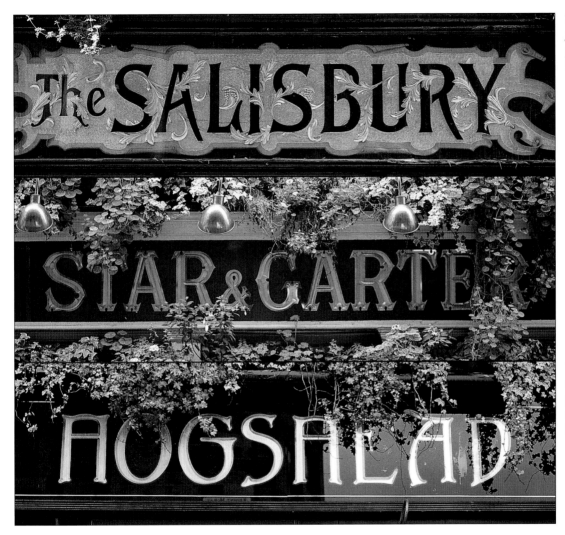

Victorian gilded and etched glass public house facade. Glasgow, Scotland, late 19th century.

Top left: *Painted glass shop door. Vienna, late 19th century.*
Top right: *Gilded public house sign. London, late 19th century.*

Center left and right: *Gilded lettering, glass door. Barcelona, late 19th century.*

76

Bottom left: *Tuscan letterforms, pharmacy. Bath, England, late 19th century.*

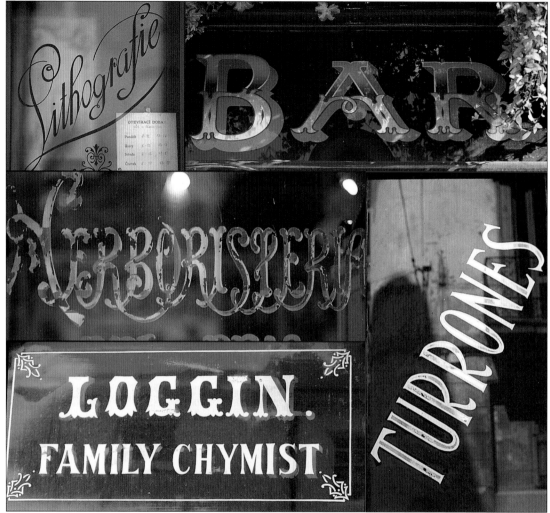

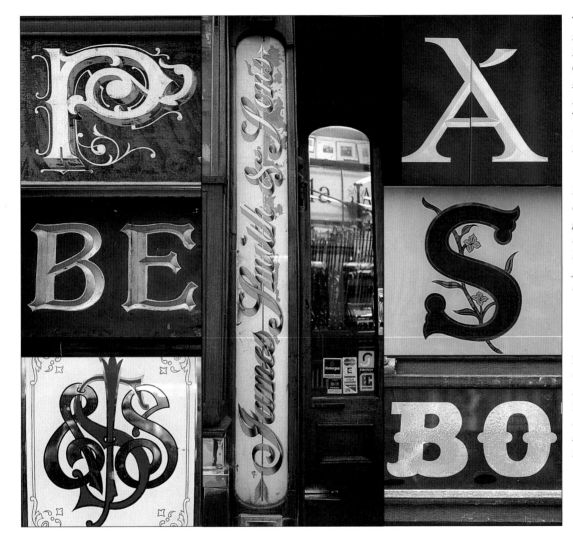

Top left: *Gilded initial "P," patisserie. Paris, late 19th century.*
Center: *Gilded umbrella shop sign. London, 1860.*
Top right: *Gilded carved wood behind glass. Prague, 1900s.*

Middle left: *Detail, carved gilded wood behind glass, public house sign. London, late 19th century.*
Middle right: *Initial "S," James Smith & Sons. London, 1860.*

Bottom left: *Gilded initials "S J & S." London, 1860.*
Bottom right: *Detail, gilded letters, shop facade. Paris, 1890s.*

Gilded glass pastry shop facades:
Left: *Paris, late 19th century.*
Top center: *Vienna, late 19th century.*
Bottom center: *Paint on glass baker shop sign. Paris, late 19th century.*
Right: *Paris, late 19th century.*

78

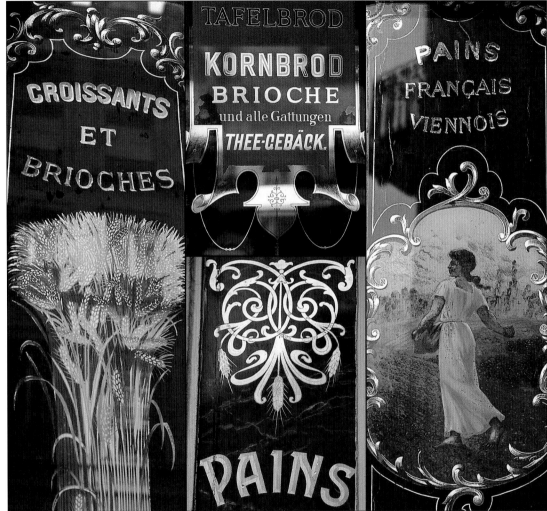

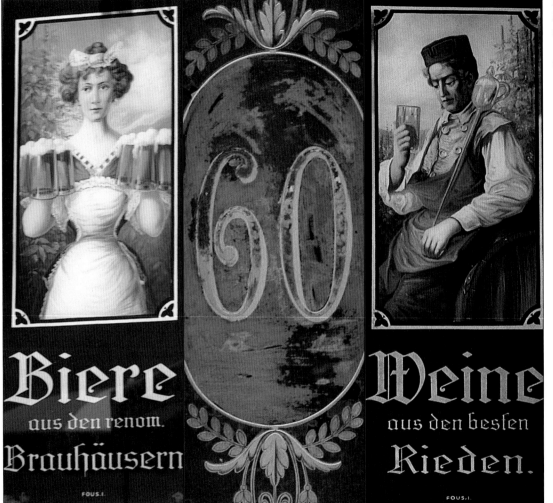

Left and right:
Paint on glass
tavern signs.
Vienna, late 19th century.
Center: *Shop number.*
Vienna, late 19th century.

Biere

aus den renom.

Brauhäusern

FOUS.I.

Weine

aus den besten

Rieden.

FOUS.I.

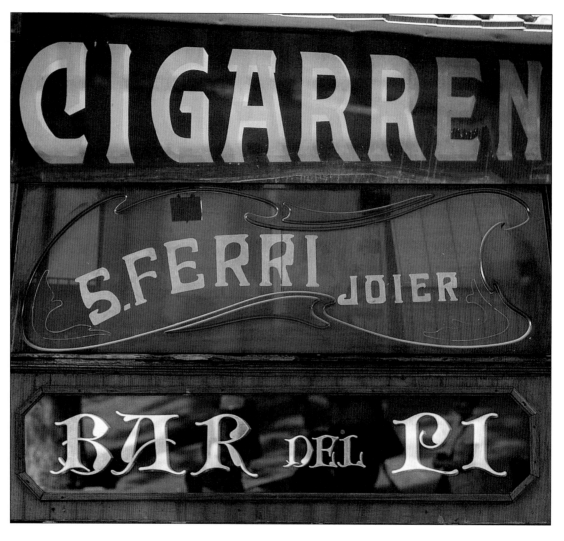

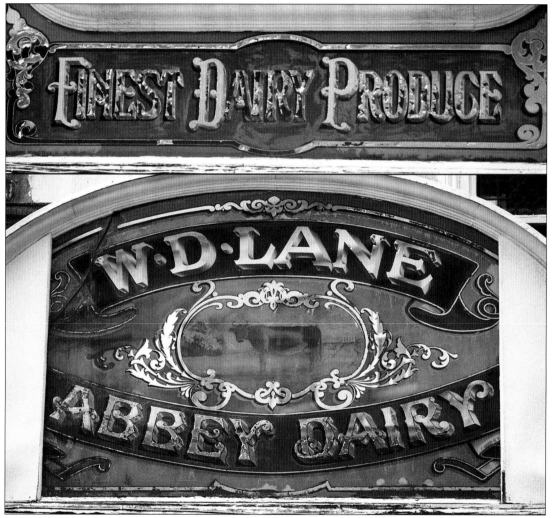

Gilded signs, dairy.
Bath, England, 1880s.

Facade,
chocolate manufacturer.
Naples, late 19th century.

Detail, shop facade.
Madrid, late 19th century.

Facade, cafe.
Barcelona, late 19th century.

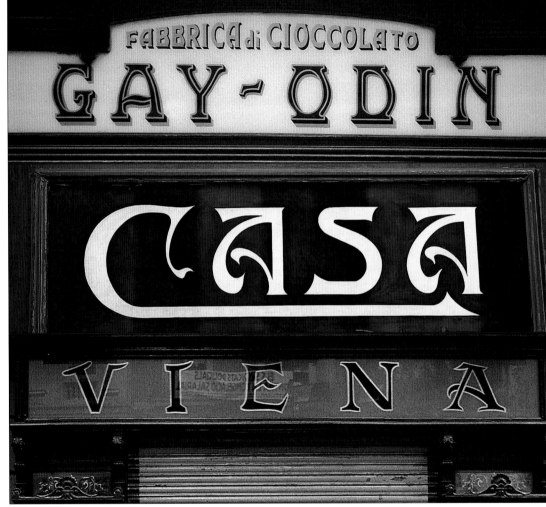

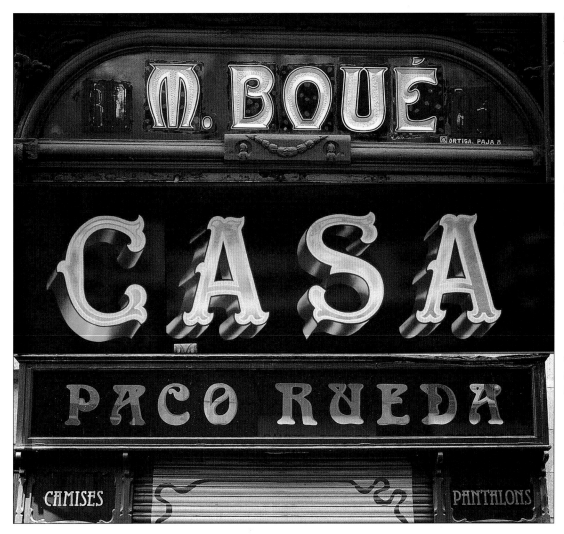

Gilded carved lettering,
jewelers shop facade.
Barcelona, late 19th century.

Gilded lettering,
clothing store facade.
Barcelona, late 19th century.

83

Gilded lettering,
clothing store facade.
Barcelona, late 19th century.

84

Leaded glass theater marquee. London, late 19th century.

Leaded glass theater marquee. Bristol, England, 1920s.

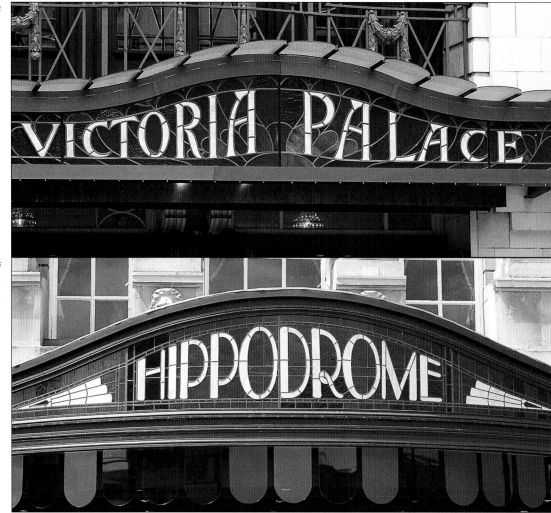

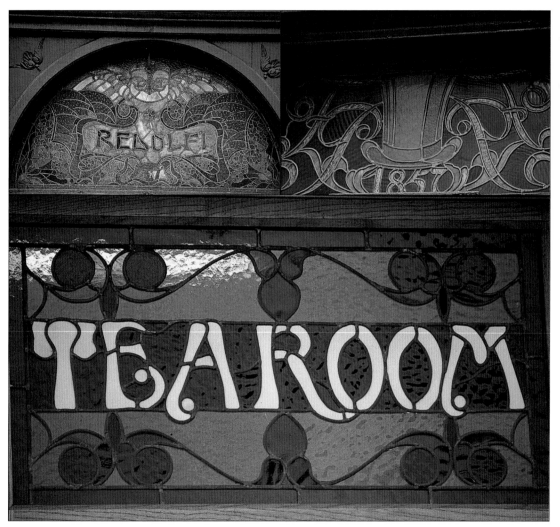

Top left: *Leaded glass fanlight. Prague, late 19th century.* **Top right:** *Leaded glass fanlight, hat shop. Copenhagen, 1857.*

Leaded glass fanlight, tearoom window. London, late 19th century.

Top left and right:
*Leaded glass,
pastry shop windows.
Barcelona,
late 19th century.*

Bottom:
*Leaded glass,
realtor's office.
Glasgow, Scotland, 1930s.*

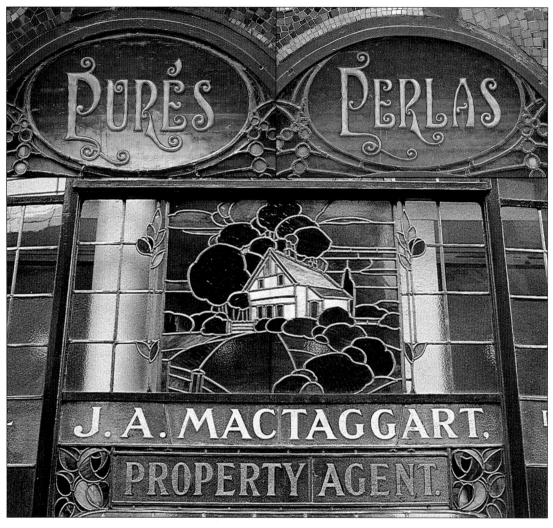

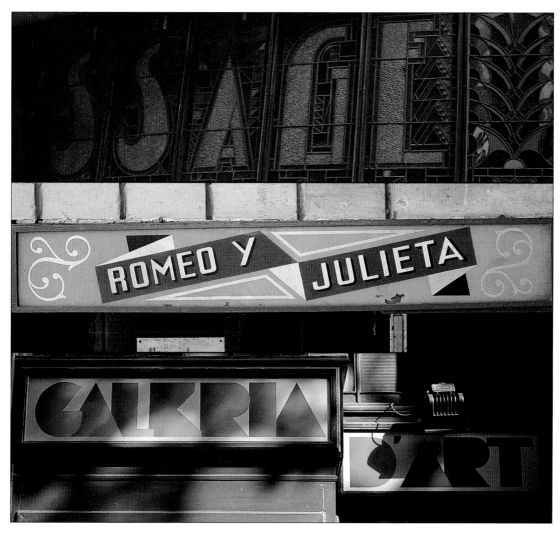

Leaded glass window,
Theater Passage.
Architect: Jos. Duynstee.
The Hague, Netherlands,
1929.

Tobacconist shop,
cigar advertising sign.
London, 1930s.

Facade, Sala Dalmau
art gallery.
Barcelona, 1930s.

Left: *Art deco illuminated sign, restaurant. Brussels, 1930s.*
Top right: *Sandblasted glass window, pastry shop. Barcelona, 1930s.*

Bottom right: *Art deco sign painted on glass, cafe. Glasgow, Scotland, 1930s.*

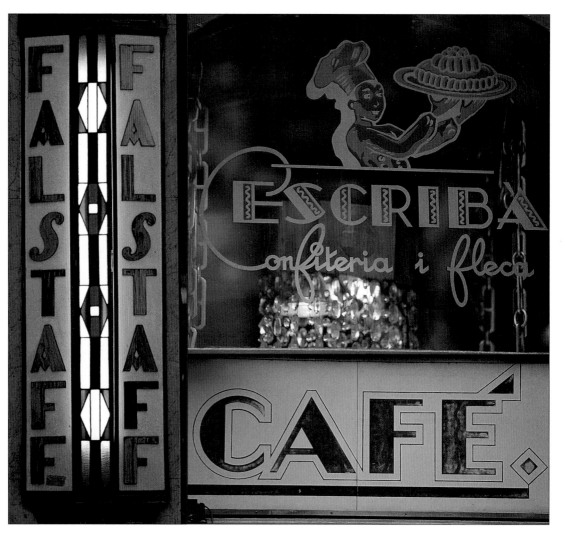

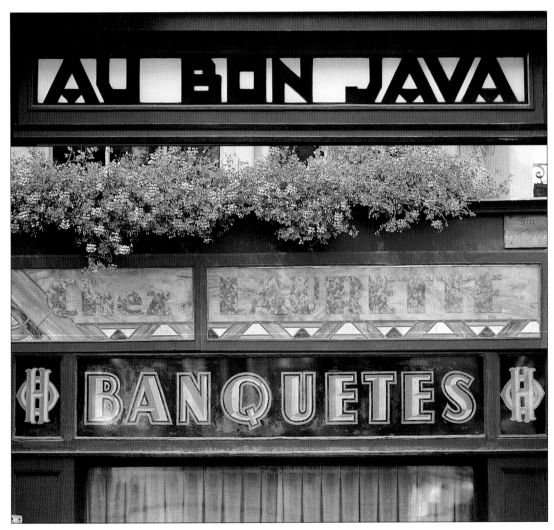

*Art deco illuminated
shop facade.
Brussels, 1930s.*

*Gilded glass
restaurant facade.
Honfleur, France, 1930s.*

89

*Gilded dimensional
lettering, restaurant facade.
Barcelona, 1930s.*

*Art deco leaded glass,
pastry shop window.
Brussels, 1930s.*

*Leaded glass,
shop window.
Brussels, 1930s.*

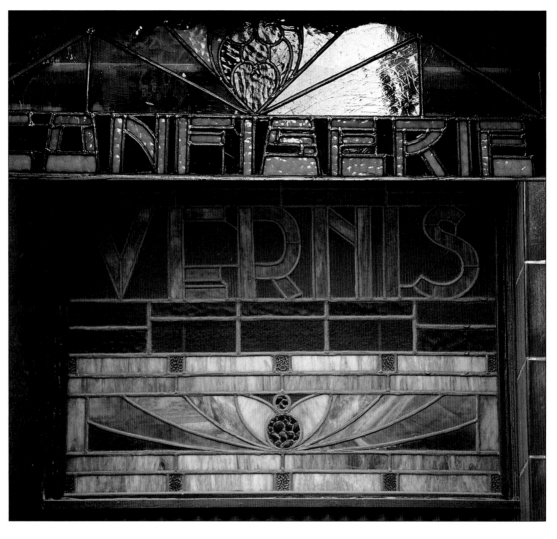

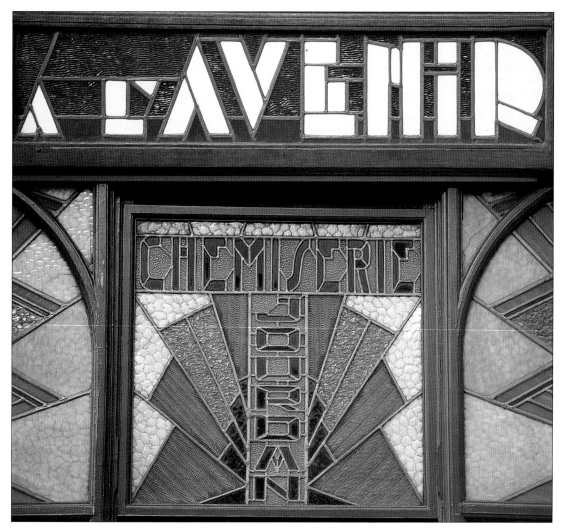

*Art deco leaded glass,
shop window.
Brussels, 1930s.*

*Leaded glass,
shop window.
Brussels, 1930s.*

91

Neon sign,
Alex Theatre.
Architect:
S. Charles Lee.
Glendale, USA, 1940.

Neon sign,
Orpheum cinema.
Architect:
G. Albert Landsburg.
Los Angeles, 1926.

92

Neon sign,
Pantages Theater.
Architect: B. Marcus Priteca.
Los Angeles, 1929.

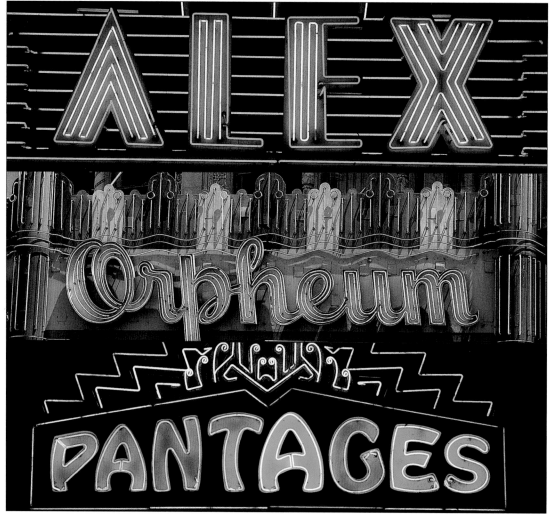

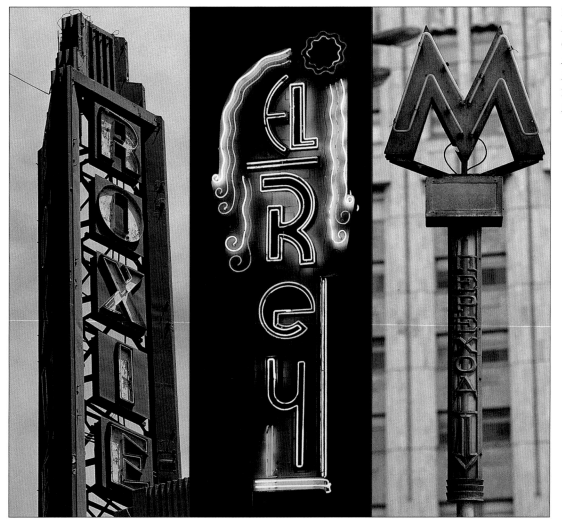

Left: *Roxie cinema tower.*
Los Angeles, 1930s.
Center: *El Rey cinema.*
Architect: W. Clifford Balch.
Los Angeles, 1936.
Right: *Metro sign.*
Moscow, 1930s.

93

Left: *Neon sign on 120-ft. high tower for cinema. Architect: Thomas Braddock. London, 1937.*
Top and bottom right: *Neon signs, hotels. Miami, 1930s.*

94

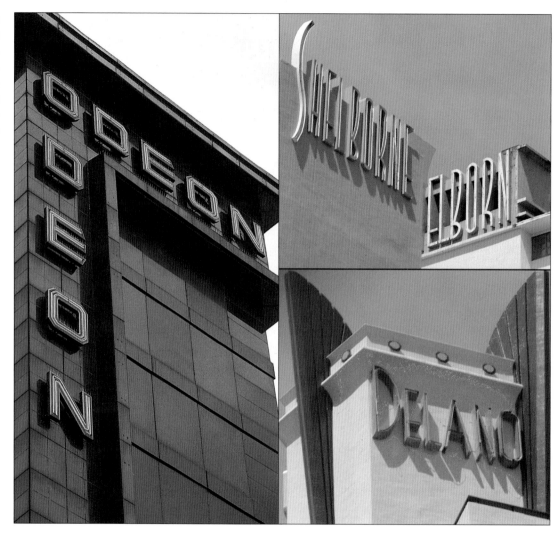

Opposite: *Neon sign, kosher butcher shop window. New York City, 1940s.*

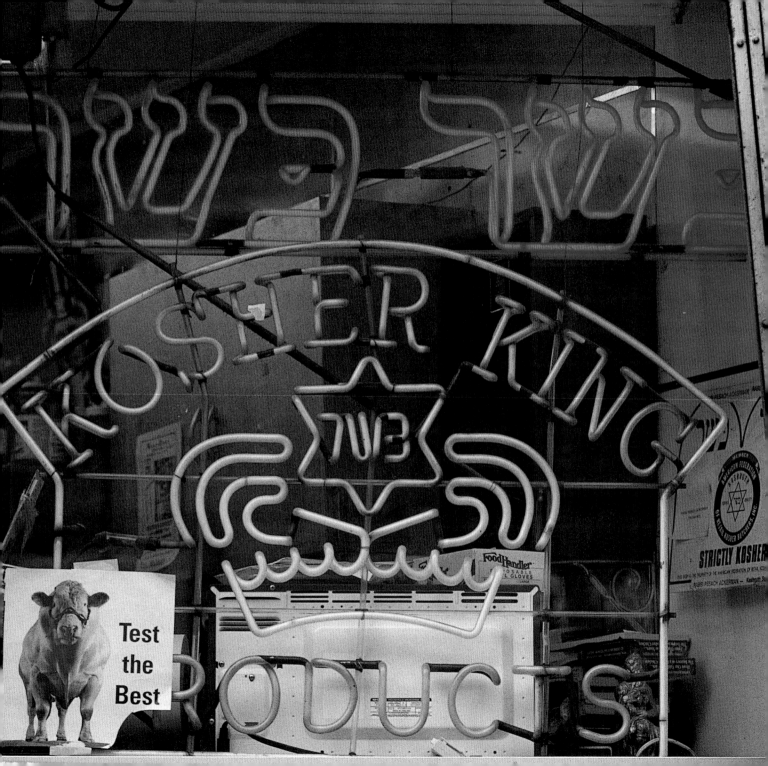

Inset: Letter "P,"
with drop shadow.
Venice, Italy,
late 19th century.

PAINTED SIGNS, USUALLY UPON WOOD, grew to their zenith in the late nineteenth century. Advertising signs were widely painted on walls in the United States and even more so in France, where virtually every available meter of wall space of both private houses and businesses would have its *Dubonnet* or *Nicolas* advertisement. Fading remnants of these are still much in evidence today.

One can also still see the rare signwriter on a ladder practicing the craft with brush, palette, and maulstick. One of the surviving aspects of this art is in the beautiful white painted cursive scripts upon the windows of Amsterdam's "brown cafes" (public houses); and in Great Britain, the traditional folk art continues in the ornate shaded lettering upon canal barges, haulage trucks, and steam rollers. In the city of York's Railway Museum, there are extraordinary examples of the Victorian lettering craftsmen's shaded and dimensional artwork upon the sides of steam trains.

In Austria, Poland, and the Czech Republic, for centuries buildings such as the fifteenth-century Rott House in Prague have been decorated with intricate letter forms. Fine specimens of simple sans serif lettering on the many quayside fish warehouses have recently been removed to make way for the revitalized Manhattan's South Street Sea Port. In Paris, Hector Guimard's art nouveau Metropolitan subway signs are still prominent in the cityscape.

Stock wood letters that became popular in the late nineteenth century lent themselves perfectly to the heavy Egyptian-style letter forms, with their square cut slab serifs, as in Wards, The Seedsmen's shop, in Bath, England. This Georgian period city is still rich with painted lettered walls and stone-carved street names.

Opposite: Painted
sans serif lettering
on brick wall.
New York City, 1940s.

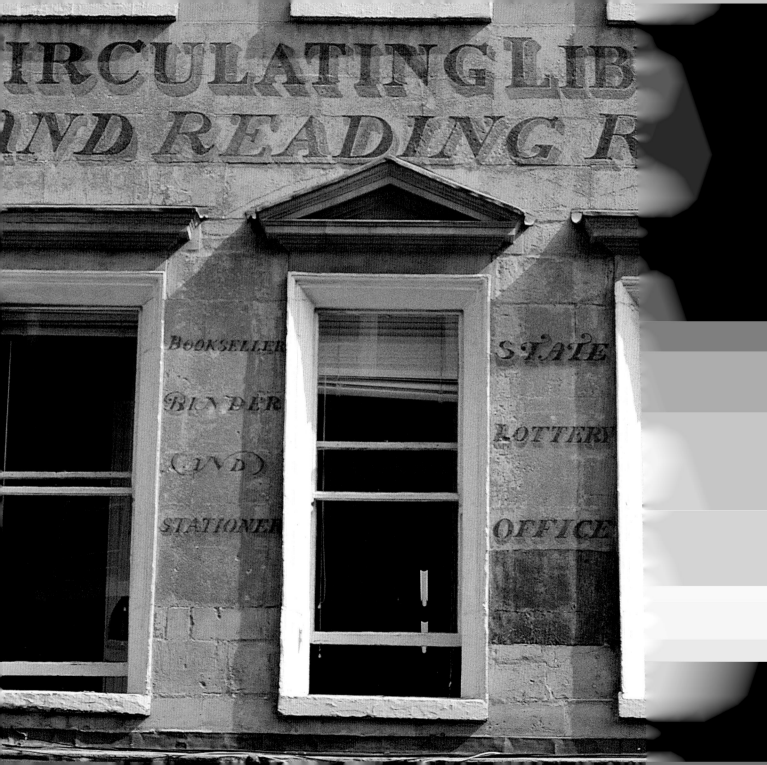

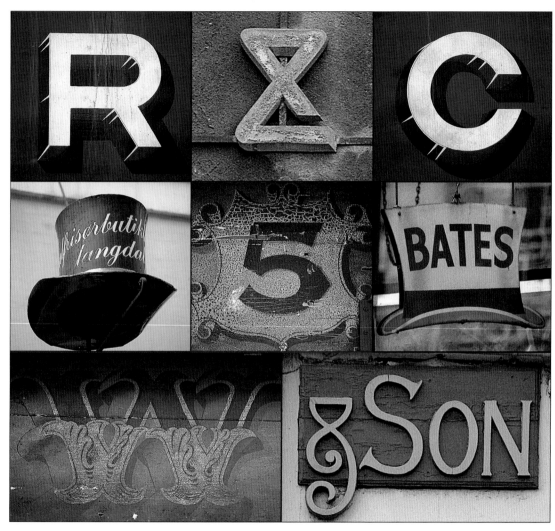

Top left and right:
Details, dimensional lettering on railway engine. Cairngorm, Scotland, 1930s.
Top center:
Gilded wooden ampersand. Madrid, 1900s.

Left: *Painted script on metal hanging sign, hat shop. Copenhagen, mid-19th century.*
Center: *Detail, shop number. London, mid-19th century.*
Right: *Hanging sign, hat shop. London, late 19th century.*

Left: *Detail, Tuscan-style lettering, shop facade. London, mid-19th century.*
Right: *Detail, builder and decorator's facade. York, England, late 19th century.*

Opposite: *Painted library facade. Bath, England, early 19th century.*

Left: *Paint on wood, baker's shop sign. Amsterdam, mid-19th century.*
Top center: *Detail, hanging sign board, covered market. Oxford, England, mid-19th century.*
Bottom center: *Painted entrance sign, Glasgow School of Art. Architect: Charles Rennie Mackintosh. Glasgow, Scotland, 1897–99.*
Right: *Tuscan-style lettering, shop advertisement on wall. Barcelona, mid-19th century.*

100

Painted facade, Renaissance style, hardware store. Prague, late 19th century.

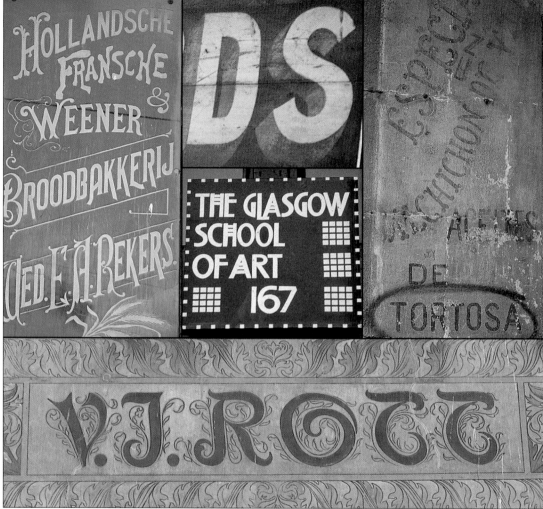

Opposite: *Contemporary painted door pediment, in the style of Alphonse Mucha. Prague, 1966.*

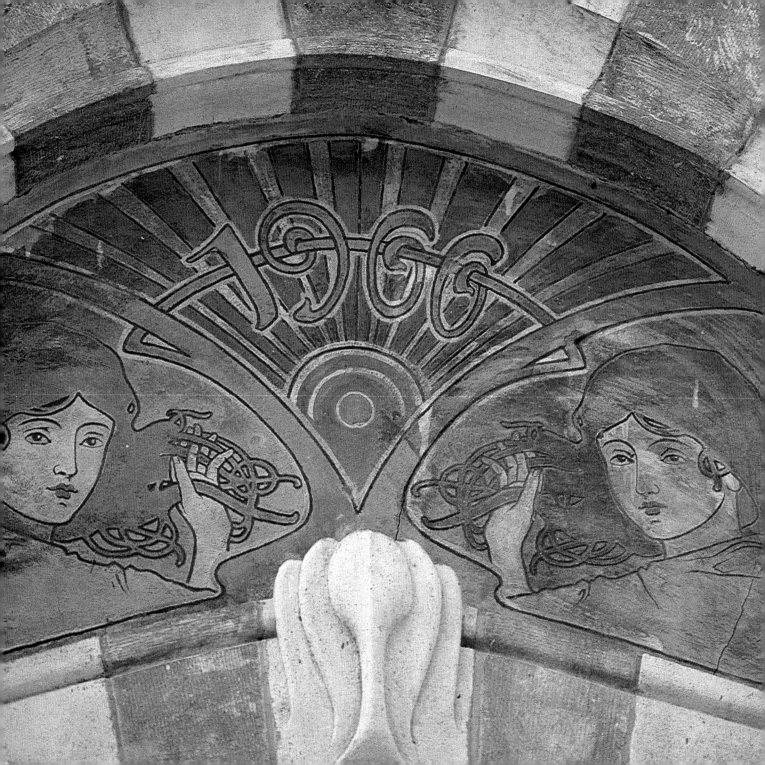

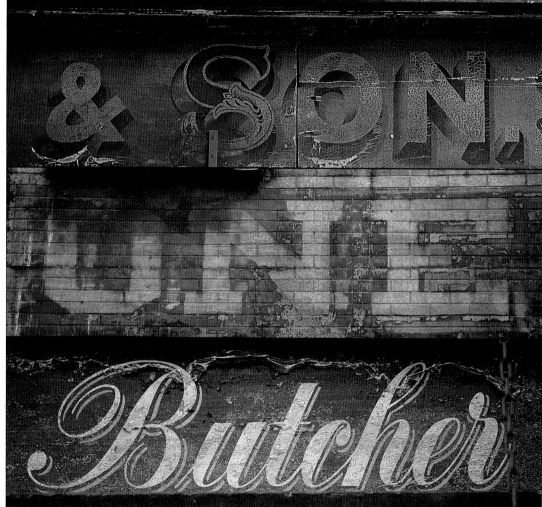

Detail,
Tuscan-style initial "S,"
painted shop facade.
London, late 19th century.

Painted wall, "Egyptian"
slab serif lettering.
New York City,
late 19th century.

102

Detail, painted on
wood facade, butcher shop.
Woodford, England, 1900s.

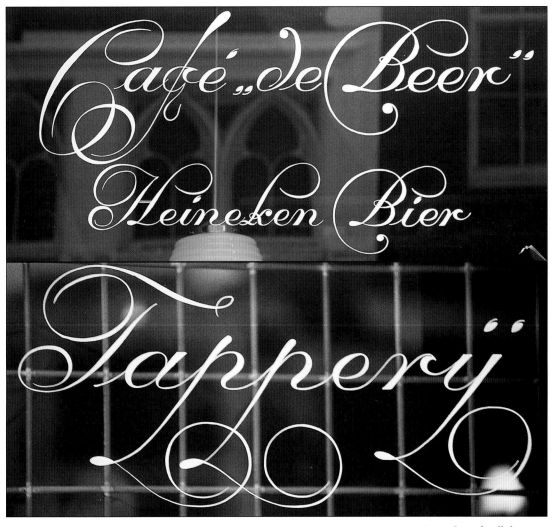

*Traditional "Brown cafe"
(public house) script
painted on glass.
Amsterdam, 1970s.*

Over: *Painted wall shop sign.
Paris, late 19th century.*

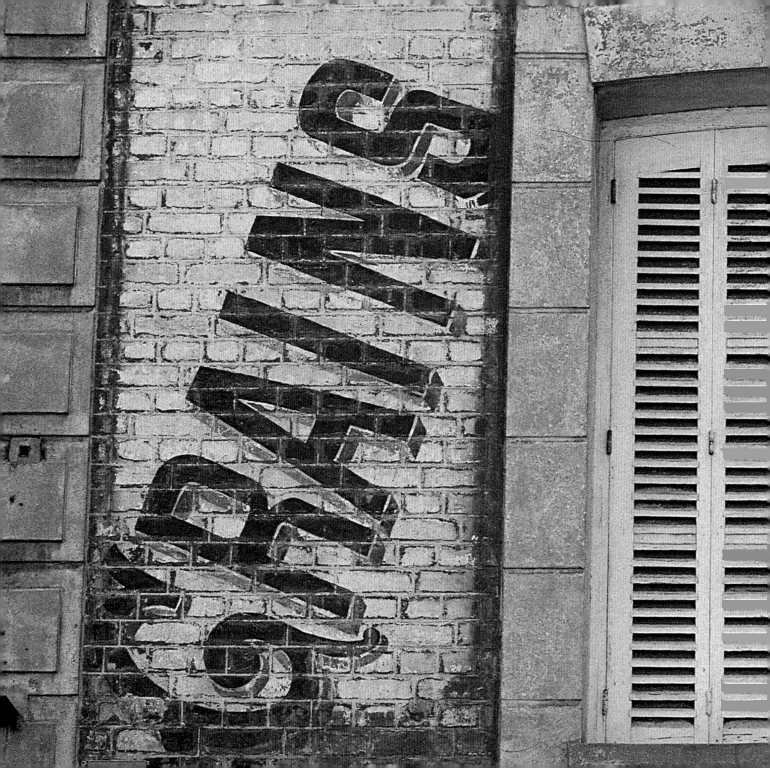

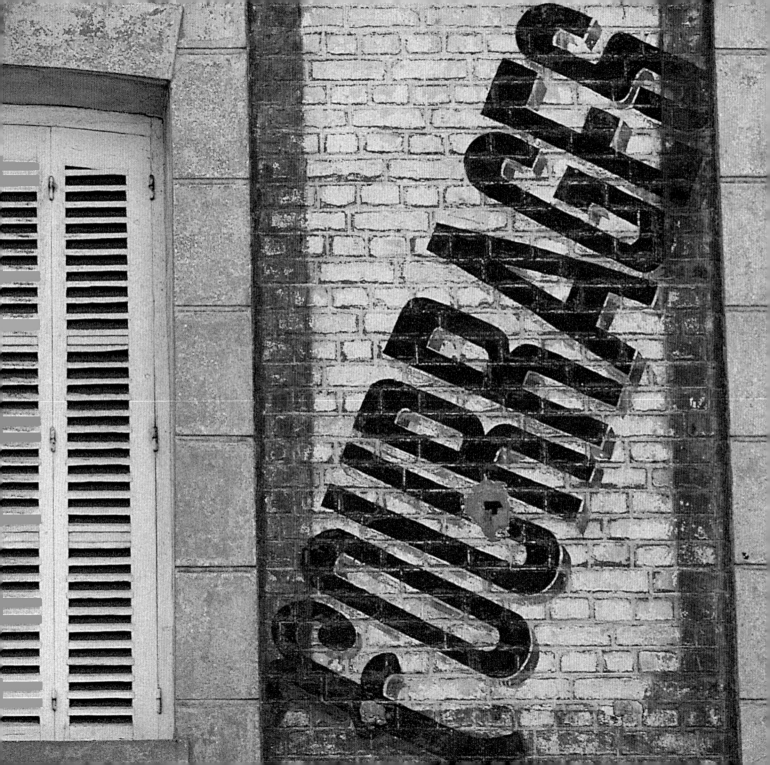

Left: *Trompe l'oeil lettering painted on plaster, shop doorway. Blois, France, 1920s.*
Top right: *Paint on wood shop sign. Blois, France, mid-19th century.*

106

Bottom right: *Paint on metal sign. Paris, late 19th century.*

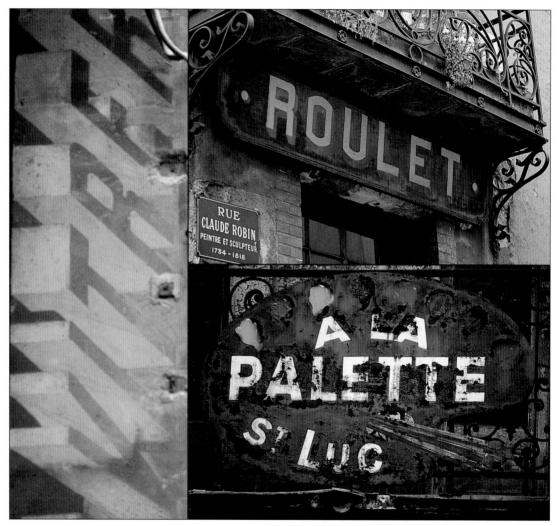

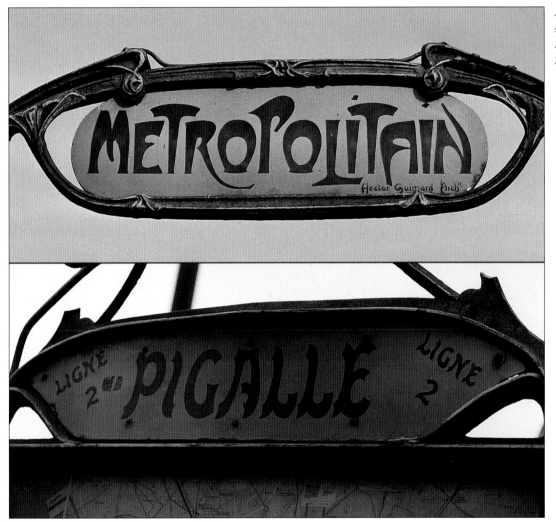

*Art nouveau Metro
subway signs.
Designed by Hector Guimard.
Paris, 1900s.*

Painted shop sign on wall. Vienna, 1890s.

"Fraktur" lettering on stone. Vienna, late 19th century.

108

Paint on wood shop sign. Vienna, late 19th century.

Opposite:
Wooden restaurant sign with "Fraktur" lettering. Vienna, 1900s.

Zum

Ziglmüller

5
Lugeck

*Tuscan-style sign
painted on wood.
Paris, late 19th century.*

*Tuscan-style sign
painted on wood.
Barcelona, late 19th century.*

*Tuscan-style sign
painted on wood.
Paris, late 19th century.*

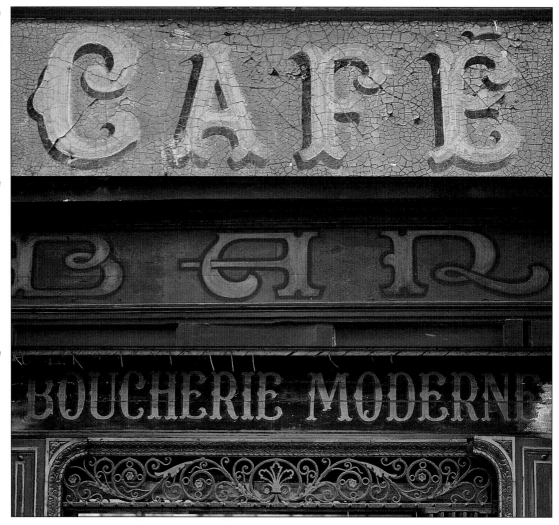

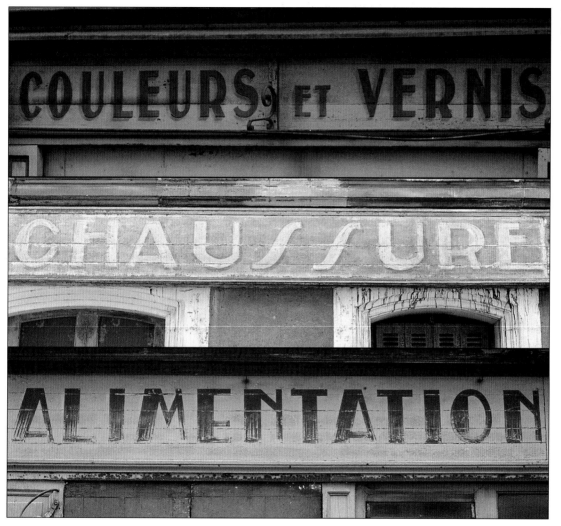

Three paint on wood shop facades. Paris, 1930s.

111

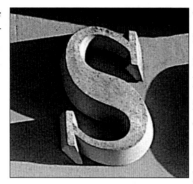

Inset: *Stone perspective
initial letter
with slanted return.
London, mid-19th century.*

TONE IS MAN'S EARLIEST-KNOWN MATERIAL. The first inscriptions were made in Mesopotamia around the third millennium B.C. on baked clay tablets. This form of writing, known as cuneiform, consisted of a series of straight lines, as it was difficult to produce curves with a wood or reed stylus. These letter forms were followed by the Persian and ancient Egyptian intaglio reliefs. The alphabet as we know it today was perfected by the Romans, and the inscription at the base of the Trajan column in Rome is looked upon today as the purest example of the Roman alphabet.

Many seventeenth-century French chateaux utilized stone in the elaborate open-work Latin inscriptions upon their balustrades. This lettering tradition was carried over to Great Britain's many grand country estates. The circa 1800 Georgian street-name signs in Bath, England, emulate these perfect Roman letter forms.

Stone-lettered facades were commonplace in the late nineteenth century. The 1920s and 1930s saw some superb examples of art deco letter forms in this medium. Two of the largest are the stone-relief sculpted name of London's Barkers department store and the Oxo Tower, with its latticework windows spelling out the company name. Once the headquarters of the well-known beef extract company, this Thames-side landmark is now a restaurant.

In Los Angeles, George Stanley sculpted both the inscription above the street entrance of the Bullocks Wilshire department store and the "Three Muses" entry fountain to the Hollywood Bowl, which has its name incised in light, open, sans serif letters. Stanley was also the sculptor of the "Oscar" statuette.

Opposite: *Sans serif
stone-relief letters,
Barkers department store.
London, 1925.*

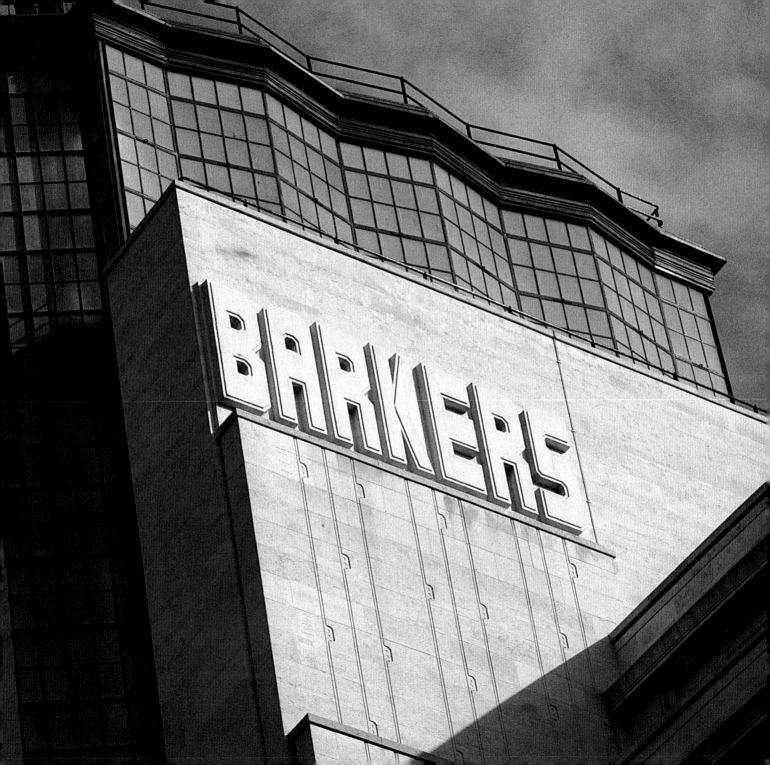

Low relief cut-stone lettered facade, School of Architecture. Bucharest, Rumania, late 19th century.

Stone Tuscan lettering, Leadenhall market. Architect: Sir Horace Jones. London, 1881.

Incised marble. Copenhagen, late 19th century.

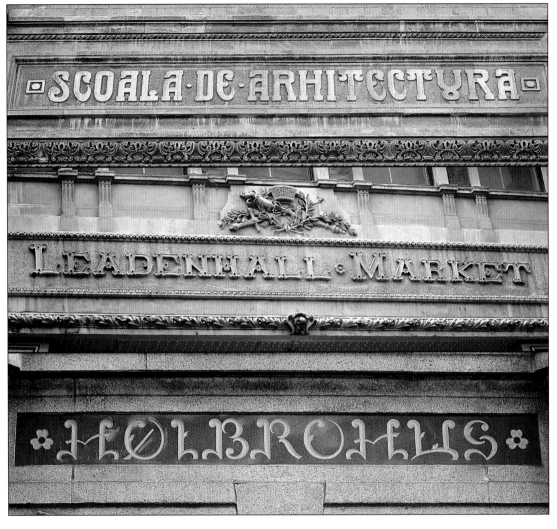

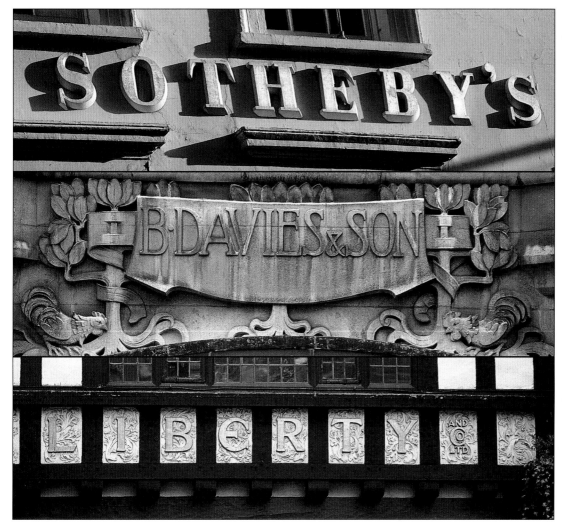

Stone perspective lettering
facade, auctioneers
sale rooms.
London, mid-19th century.

Arts and crafts
shop facade.
London, late 19th century.

Mock Tudor facade,
Liberty's department store.
Architects:
E. T. and E. S. Hall.
London, 1924.

Chateau balustrade
lettering, "Ave Maria."
Loire Valley, France,
17th century.

Detail, incised-stone
frieze, seminary.
London, 19th century.

Relief stone-cut letters.
London, mid-19th century.

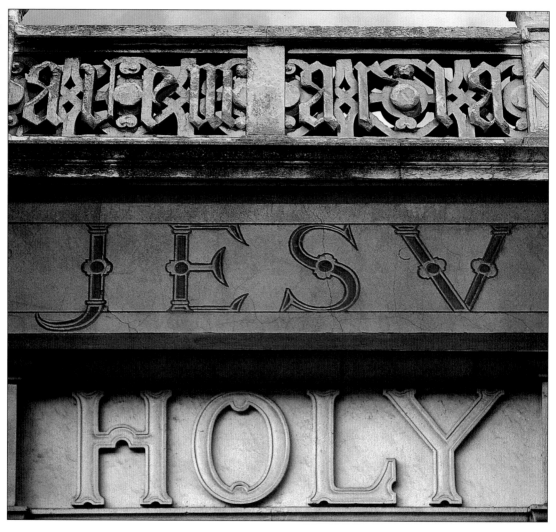

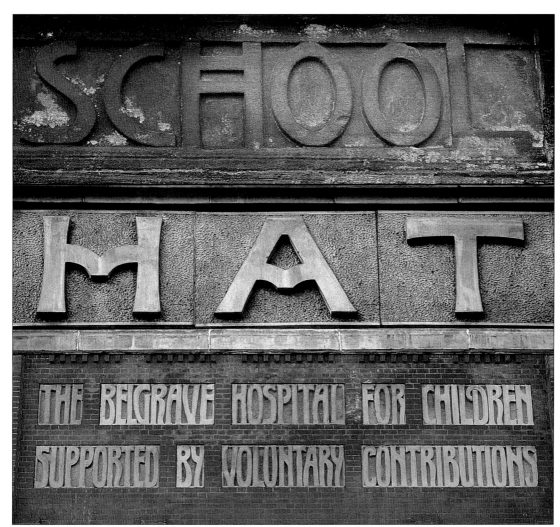

Detail, stone wall,
Scotland Street School.
Architect: Charles Rennie
Mackintosh.
Glasgow, Scotland, 1904.

Detail, stone-relief facade,
Henry Heath hat factory.
London, late 19th century.

Art nouveau low-relief
inscription, hospital.
Designer: Charles Holden.
London, 1906.

*Victorian stone-relief facade.
Fremantle,
Western Australia,
late 19th century.*

*Victorian stone-relief facade.
Fremantle,
Western Australia,
late 19th century.*

118

*Victorian stone-relief facade.
Perth, Western Australia,
late 19th century.*

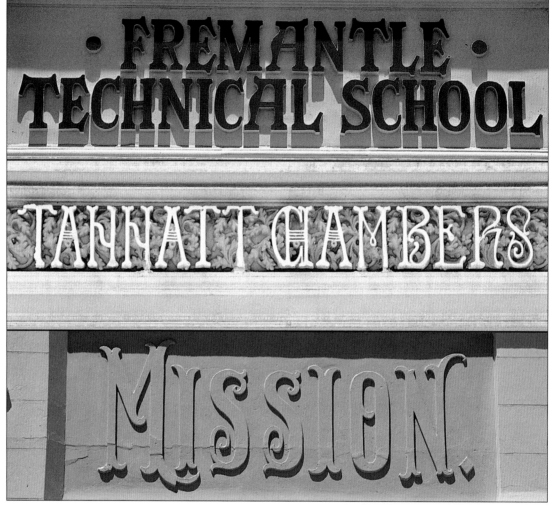

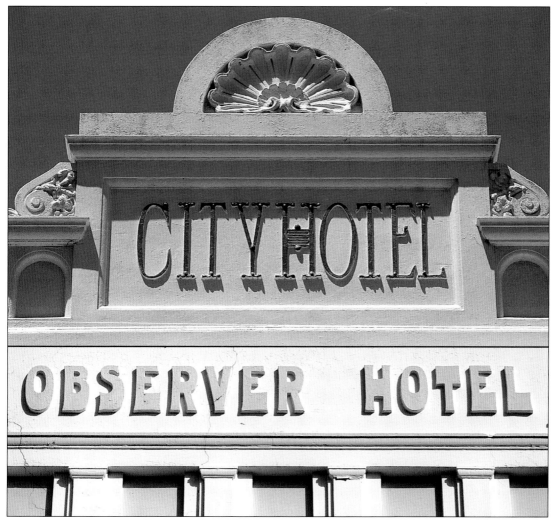

Victorian corbel
low-relief facade.
Fremantle,
Western Australia,
late 19th century.

Art nouveau
stone-relief facade.
Sydney, Australia,
late 19th century.

Top left: *Shop numerals. New York City, late 19th century.*
Top center: *Stone plaque, apartment building, Fifth Avenue. New York City, mid-19th century.*
Top right: *Shop numeral. London, late 19th century.*

Left: *Victorian stone-relief date, apartment building. London, 1888.*
Right: *Shop number, pharmacy. Copenhagen, 1900s.*

Bottom right: *Incised in slate and gilded house number. Prague, 18th century.*

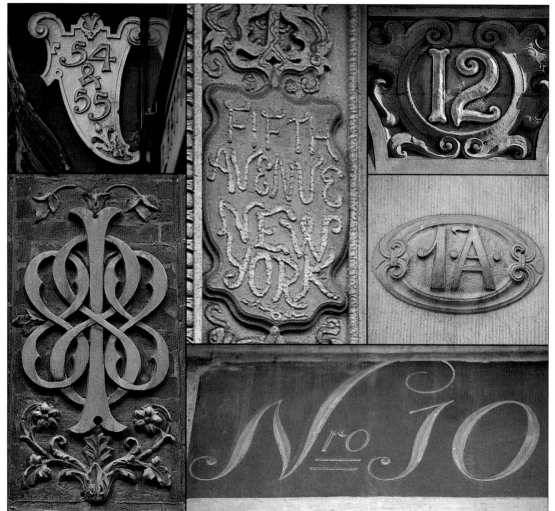

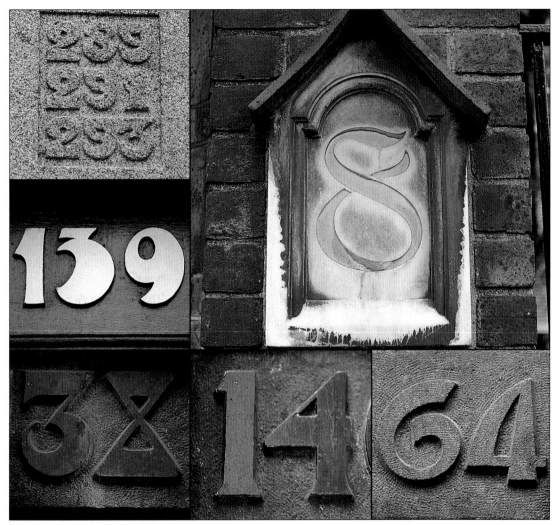

Top left: *Stone apartment numbers. Amsterdam, 1920s.*
Top right: *Art nouveau incised house number, Debenham House. Architect: Halsey Ricardo. London, 1905.*

Center left and bottom row: *Relief house numbers. Amsterdam, 1920s.*

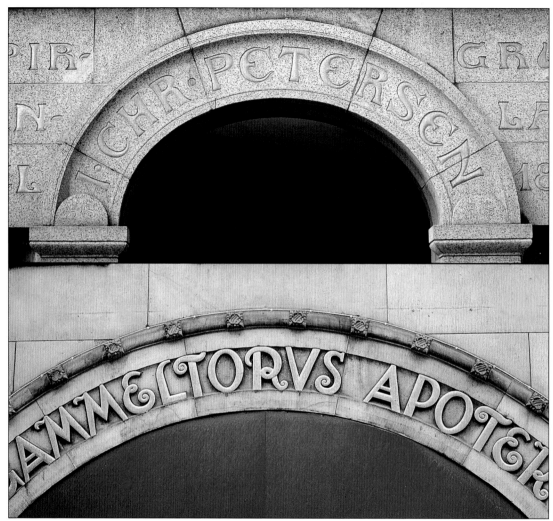

Incised lettering, granite arch. Copenhagen, late 19th century.

122

Gilded relief stone lettering, pharmacy. Copenhagen, late 19th century.

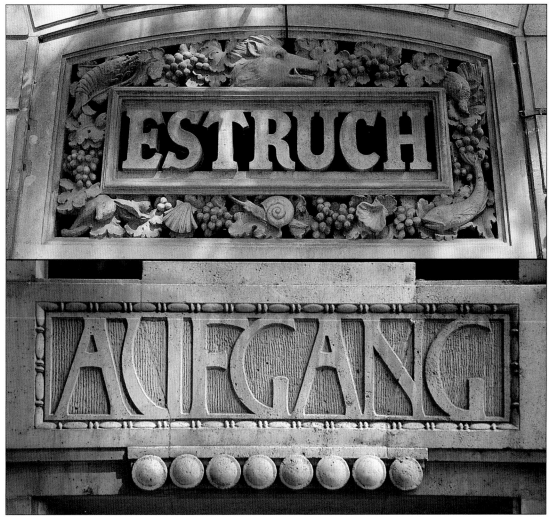

Lattice stone lettering,
restaurant.
Barcelona, late 19th century.

Jugendstil stone-relief
exit sign,
pedestrian bridge.
Vienna, late 19th century.

Stone frieze,
Hebrew characters,
Kazinczy utca Synagogue.
Budapest, 1913.

Art nouveau
stone entablature,
Christian mission.
London, late 19th century.

Stone entablature
mock Hebrew lettering,
Jewish institution.
New York City, 1900s.

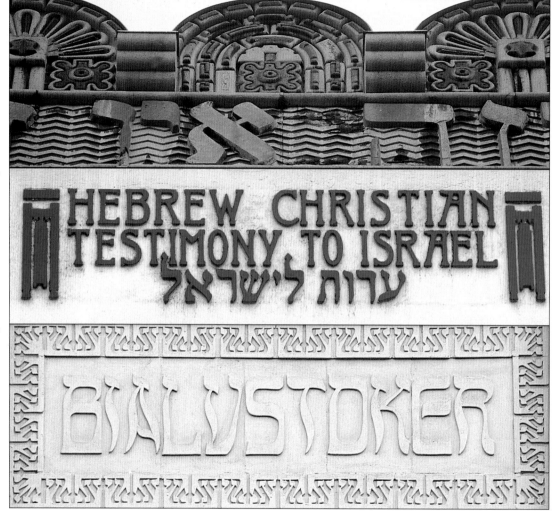

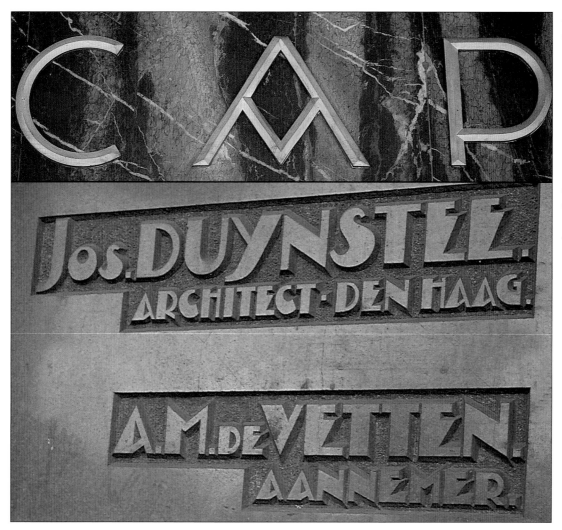

*Detail, gilt letters
incised in marble.
Vienna, 1930s.*

*Art nouveau
architect's plaque,
Theater Passage.
Architect: Jos. Duynstee.
The Hague, Netherlands,
1929.*

125

Relief stone sign,
service entrance.
Amsterdam, 1920s.

Relief stone mail slot.
Amsterdam,
late 19th century.

Relief stone sign.
Amsterdam, 1920s.

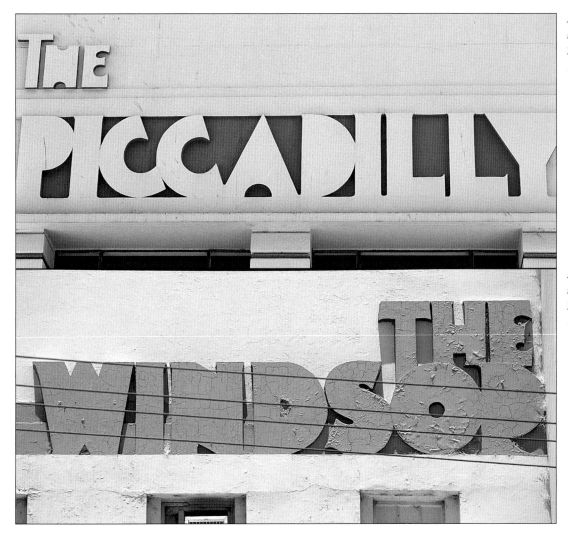

Art deco stone-relief
movie house facade.
Perth, Western Australia,
1930s.

Art deco stone-relief
movie house facade.
Perth, Western Australia,
1930s.

Carved stone
low-relief, "Wisdom."
Former RCA Building.
Designer: Lee Lawrie.
New York City, 1931.

128

Opposite: Terra-cotta facade,
Bullock's Wilshire
department store.
Architects: John and
Donald Parkinson.
Sculptor: George Stanley.
Los Angeles, 1928.

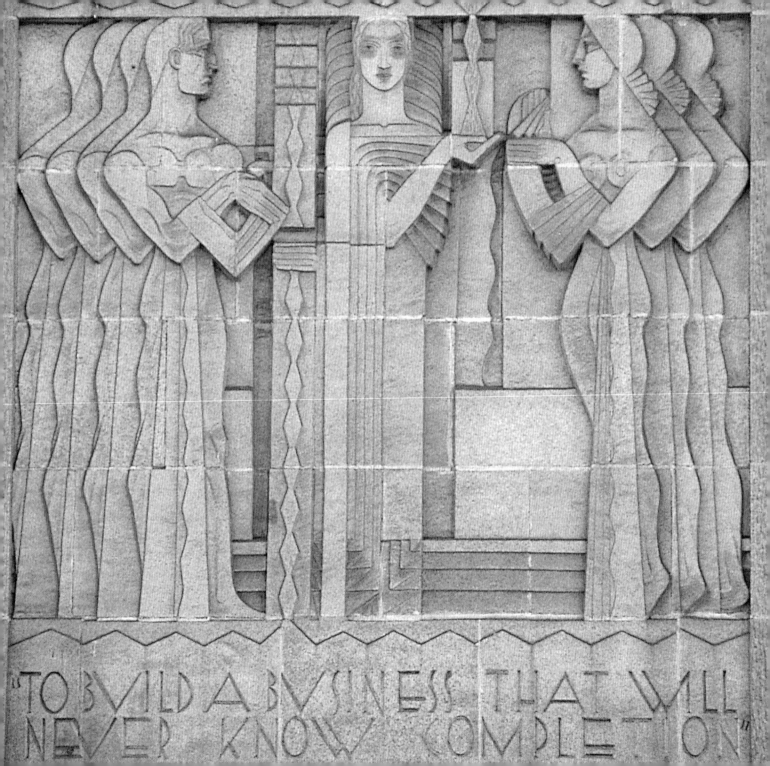

"TO BVILD A BVSINESS THAT WILL
NEVER KNOW COMPLETION"

Detail, relief stone facade,
Electric City.
Brussels, 1930s.

Relief entablature,
police station.
London, 1930s.

130

Building facade,
Faraday House.
London, 1930s.

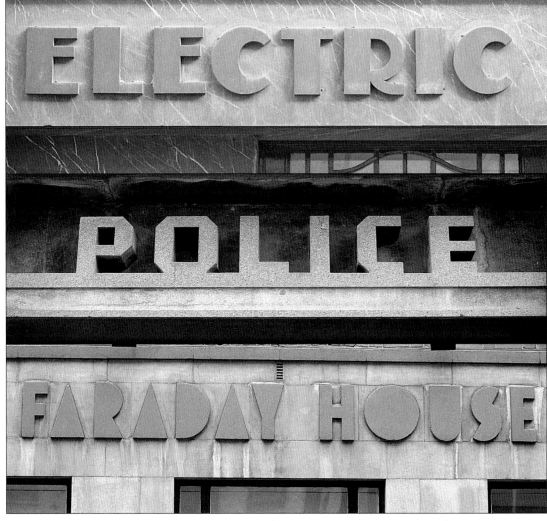

Opposite: *Art deco cast stone exit signs.*
Left: *New Victoria cinema.*
Architects:
E. Wamsley Lewis and W. E. Trent.
London, 1930.
Right: *Ambassador Hotel.*
Los Angeles, 1938.

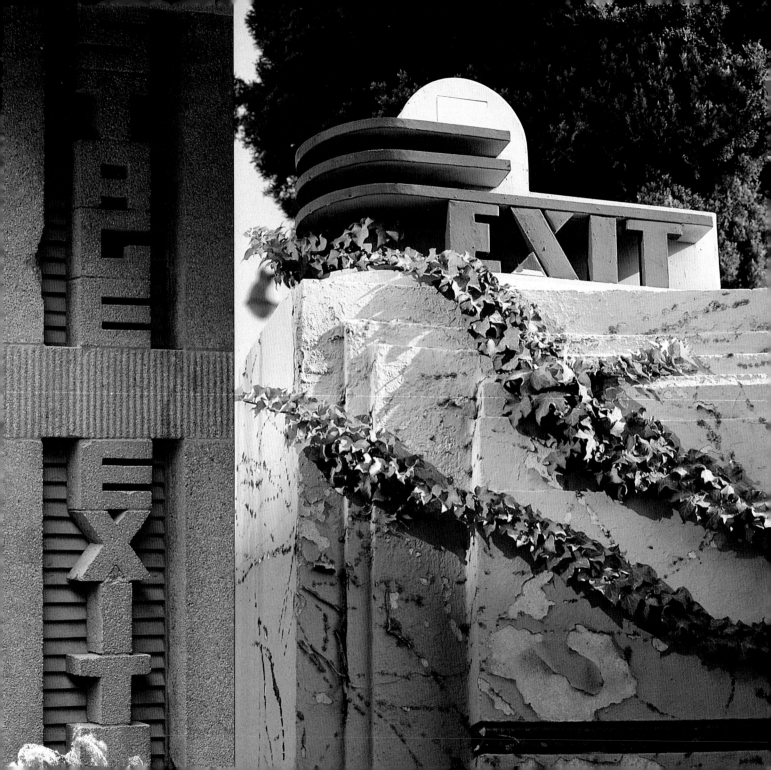

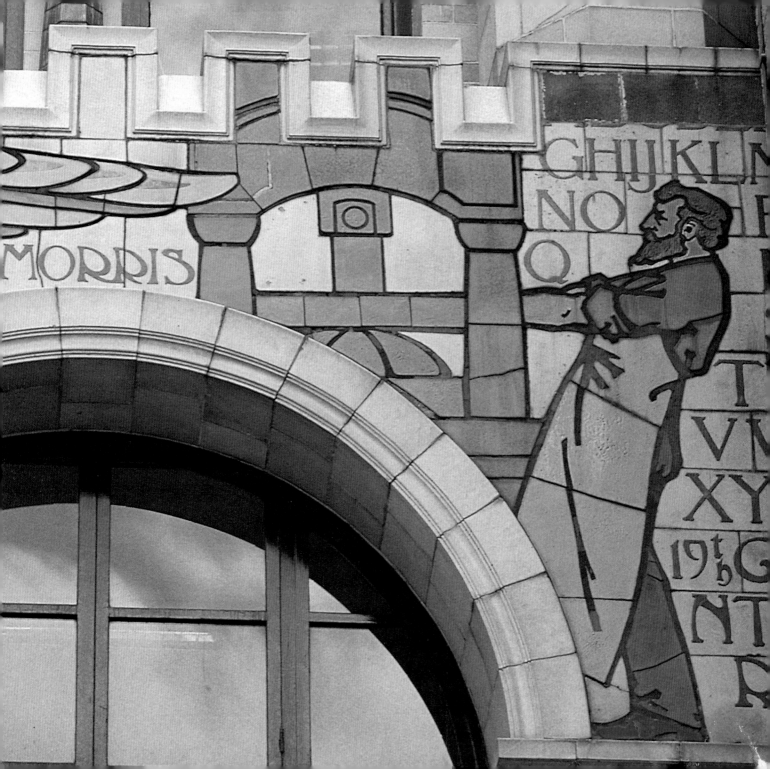